ON THE STUDY OF
Indian Art

The Polsky Lectures in Indian and
Southeast Asian Art and Archaeology

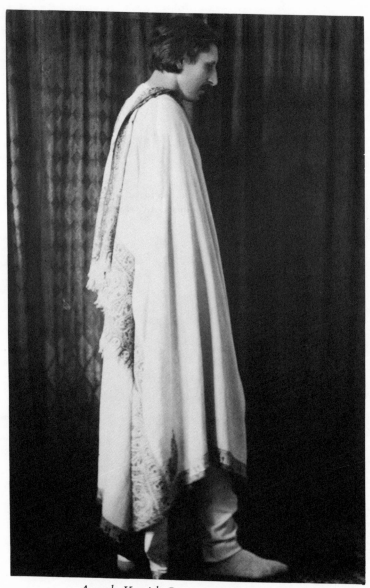

Ananda Kentish Coomaraswamy (1877–1947).

ON THE STUDY OF

Indian Art

P R A M O D C H A N D R A

Published for the Asia Society by
HARVARD UNIVERSITY PRESS
Cambridge, Massachusetts
and London, England
1983

Copyright © 1983 by the Asia Society
All rights reserved
Printed in the United States of America
10 9 8 7 6 5 4 3 2 1

This book is printed on acid-free paper,
and its binding materials have been
chosen for strength and durability.

Library of Congress Cataloging in Publication Data

Chandra, Pramod.
On the study of Indian art.

(The Polsky lectures in Indian and
Southeast Asian art and archaeology)
Bibliography: p.
Includes index.
1. Art, Indic. I. Title. II. Series.
N7301.C474 1983 709'.54 83-8393
ISBN 0-674-63762-3

Designed by Gwen Frankfeldt

ACKNOWLEDGMENTS

I wish to express my thanks to the Asia Society, particularly Mr. Allen Wardwell, and to the generous sponsor, Mrs. Cynthia Hazen Polsky, for the honor they did me by inviting me to deliver the three inaugural Polsky Lectures.

The lectures, and indeed the lecturer, were introduced by His Excellency Shri K. R. Narayanan, Ambassador of India to the United States of America. I am grateful for this generous act of courtesy. Dr. Rama Coomaraswamy kindly provided a photograph of his father, Dr. Ananda Coomaraswamy, whose unique scholarship looms large in the study of Indian art. The portrait, appropriately, is the frontispiece of this book. To him and to Dr. H. Sarkar of the Archaeological Survey of India, who turned up the photograph of a portrait of General Cunningham, I am deeply indebted.

CONTENTS

ILLUSTRATIONS

Frontispiece. Ananda Kentish Coomaraswamy (1877–1947). Courtesy Dr. Rama Coomaraswamy.

Following page 54

ON THE STUDY OF
Indian Art

INTRODUCTION

The study of Indian art, in the modern sense of the term, began, if somewhat fitfully, in the nineteenth century and in a European context. To be sure, Indians themselves must have in some way reacted to the great works they produced in such profusion and over great stretches of time, but, if we are to trust the fragmentary and painstaking reconstructions of modern scholarship, their efforts seem to have been of quite a different order.[1] Europeans were vaguely aware much earlier than the nineteenth century that India had some sort of art, but the notices it received, from the Middle Ages onward, whether in an artistic, religious, historical, or philosophical context, were for the most part incidental, highly subjective, and whimsical at best, and had little to do with reality. The favorite word for describing these arts was "monstrous," an epithet we find in the works of travelers who visited India as early as the fourteenth century and which persisted into the more learned essays of later explorers and archaeologists of

the twentieth century.[2] For example, the otherwise fair-minded and unbigoted Sir Aurel Stein, faced with the treasures of Tun Huang around 1912, noted with pleasure "the entire absence of those many-headed and many-armed monstrosities which the Mahayana Buddhism of the Far East shares with the later development of that cult in Tibet and the border mountains of northern India."[3] This remarkably superstitious attitude toward Indian art forms survived in the West for nearly six hundred years. However, it is not my intention here to document and denounce this and other equally wild yet surprisingly fixed ideas, nor am I to be thought of as defending the validity of Indian art as a form of creative human expression. These battles were fought and won a long time ago. I mention these prejudices simply to acknowledge their existence and thus to make it possible to discount them with ease from early studies of Indian art that otherwise contain admirable contributions to learning.

The more substantial of these studies began about a hundred and fifty years ago, and have, with ups and downs, flourished ever since. It is fitting, it seems to me, to review their nature so that we will be better able to assess where we are and, almost as important, how we got there. While one is immersed in the material on a day-to-day basis, and I speak here for myself, one tends to forget the assumptions and methods that lie at

the basis of one's thinking. Much is taken for granted, many assumptions are unthinkingly made. When one steps back, takes a deep breath, and casts what one hopes is a dispassionate look over one's scholarly fields, one is often surprised at the errors unwittingly committed. To do this in a historiographical context from time to time is doubly rewarding. It allows us first of all to assess and pay homage to the truly great contributions of previous scholars, and to realize that whatever scholarly edifices we build now would be hardly possible without the foundations laid by the early pioneers. This procedure also allows us to notice, in an atmosphere relatively free of the polemics of yesteryear, the manner in which errors of fact and method have unconsciously crept into our thinking. Additionally, it gives us an opportunity to address ourselves to the broad issues raised by the great scholarly works of the past and thus to review our own methods, their strengths and weaknesses. Unless we are conscious of what we are doing, and in some way continuously assessing, reviewing, and refining our methods, we will progress only by fits and starts. We will be not only liable to repeat and perpetuate past errors but also that much less likely to profit from the work of our predecessors and that much more likely to exaggerate the notion of original contribution on our part — a rather dangerous posture considering the extensive first-hand

knowledge of India and its people that many of our nineteenth- and early-twentieth-century scholars possessed.

I shall consider in turn studies of three genres of Indian art: architecture, sculpture, and painting. I shall begin with architecture, which was thought by the ancient Indians to be the most important of the visual arts, sculpture and painting being subsumed within it, and which also was the earliest of these arts to receive careful and analytical treatment.[4] Studies of sculpture, which began a little later and were inevitably affected by methods developed for architecture, will be the subject of the second chapter, and the study of Indian painting, of most recent beginnings and in which the most remarkable progress has been made in the last twenty-five years, will bring this book to a close. This division into architecture, sculpture, and painting is somewhat artificial, for there is often, though not always, considerable consistency in the treatment accorded by a scholar to each of them. Nevertheless, I believe the procedure adopted will make for some clarity, and that is its excuse.

Scholars of importance to us are many in number, but I have been forced to restrict myself here to a very few whose work, in my opinion, clearly represents the various stages of development of our discipline. I have thus not been able to include much work that I hold in

the highest regard, and some that I do not. Moreover, in analyzing the contributions of the few presented here, I have concentrated on the broad methodological thrust of their work and not on the details of their conclusions, however interesting and important these may be. I touch on a variety of topics, including the relationship of art history to other allied disciplines, problems presented by the various methods of classification adopted, the relevance of style, the meaning of form, the connection between artists and patrons, iconography and iconology, and such other matters as have engaged the interest of scholars. All of this I present in the hope that I have not given unintended offense and that such a survey will sharpen our sensibilities and help us as we move into the future.

ONE

Architecture

Around the close of the eighteenth century, the fixed stereotypes of Indian art long prevalent in Europe had begun to fade a little, and some tentative attempts were made to treat Indian art in a fairer and more sympathetic, though hardly a scientific manner. Some serious interest was beginning to be taken in the antiquities of the country, notably architecture, chiefly under the influence of a new generation of extraordinary "orientalists" such as A.-H. Anquetil Duperron and Sir William Jones, even though their main interests were language and literature and their ideas about art were fanciful at best.[1] The superb aquatints and paintings of William Hodges and Thomas and William Daniells (published around 1795 – 1808) had also inspired much romantic interest in the picturesque ruins of India.[2] But there was little in the air that presaged the appearance of a remarkable book, *Essay on the Architecture of the Hindus,* by one Ram Raz, an otherwise unknown — and curiously enough, not a European, but an Indian — scholar.

ON THE STUDY OF INDIAN ART

The year was 1834, one of great excitement to Indian antiquaries, for the charismatic James Prinsep, master of the mint at Calcutta and the first of the great modern historians of India, had just deciphered the Brāhmī script, an event which promised to revolutionize every aspect of the study of ancient India. This promise was realized, for in less than ten years Prinsep's unrelenting and brilliant work so arranged the previous chaos of Indian history that, in the words of Horace Hayman Wilson, his eminent contemporary and professor of Sanskrit at Oxford, "hitherto unnamed and unknown members of successive and synchronous dynasties now pass before our eyes as well defined individuals and in connected order."[3]

Ram Raz's work seems to have been part of this intellectual ferment, and was introduced as marking "an epoch not only in the history of the science of architecture, but also in that of the Hindus themselves."[4] Though the praise seems exaggerated, it is not without some substance. A reading of the book reveals a clear and sensible method whereby the author attempted to understand the form of south Indian architecture by referring to a Sanskrit work on architecture and the living practitioners of the art, traditional architectural practice being very much alive at that time. The task was not easy. Ram Raz first got hold of a text, a fragment of the now well-known *Mānasāra,*[5]

but as he was unable to understand fully its technical vocabulary, the words having different meaning in common usage, he consulted an architect practicing in the time-honoured manner, who seems to have been well acquainted with the art and with its current terminology. The text being thus made meaningful, Ram Raz wisely and cautiously proceeded to verify its accuracy by reference to surviving monuments. He was thus able to give us a remarkable knowledge of several temple forms, all precisely illustrated. There is little else one could expect from a work that was the very first of its type. What is surprising is that Ram Raz's method was not taken up and followed, as we shall see, for almost a hundred years. I am convinced that had Ram Raz been emulated earlier our present knowledge of Indian architecture would be much broader and much deeper than it is.

Ram Raz's pioneering book was followed by comprehensive work of a different order by the somewhat irascible Scotsman James Fergusson, a figure of the greatest importance in the study of Indian architecture, particularly during the nineteenth century. I shall discuss Fergusson in some detail, for it is by him that the foundation for a scientific study of Indian architecture was well and truly laid. Not that his work was free of defects, but in the context of the times it was of exceptional quality, and this in spite of what what have

been called his incorrigible prejudices and, I would add, his penchant for ill-tempered and offensive polemic, his inclination to eccentric and extreme statement, and his gratuitous espousal of Anglo-Saxon racial superiority over the Asiatic, a mentality that permitted him continually to deny conclusions regarding Indian art that flowed inexorably from the force of his own logic.[6]

When I first began to study Fergusson's opus, I was quite prepared to dislike it, having been put off by its bombast and arrogance; but after a careful perusal I could not keep myself from becoming an admirer. My first surprise was that where I had expected to find a European scholar applying to India principles developed in Europe I discovered the opposite, for what Fergusson was boldly doing was applying to European architecture, or for that matter world architecture, principles he had developed through a vigorous and direct study of the architecture of India.[7] His understanding of the subject, developed without any preconceived notions, was eminently sound; the application of theories so formulated to European architecture much less satisfactory, for there the complexity of the subject and the strength of his prejudices led him into many contradictions and grave errors. His study of Indian architecture was not entirely free of these, but the damage there was far less.

An important thing to remember about Fergusson is

that he was not a professional scholar, a sobering thought for those of us who are. He was trained to be a businessman and early in life became an indigo planter and partner in a large and prosperous commercial establishment in India. Caught up in the excitement of Prinsep's sensational clarification of Indian history and the "great progress being made in the decipherment of Indian inscriptions and the study of the antiquities of the country,"[8] Fergusson plunged into architectural researches while living in that country between 1829 and 1847. Convinced that a course of studies pursued among the monuments themselves would be far more productive than books filled with theories, he traveled extensively, and often uncomfortably.[9] He became a veritable one-man architectural survey, sketching, drawing, making plans, taking careful notes, and, above all, doing some very hard thinking. All this led to the publication of his *Rock Cut Temples of India* in 1845 and the *History of Indian and Far Eastern Architecture,* which first appeared as a part of the *History of Architecture of All Nations* in 1866. This work went through several editions, of which the 1876 edition, the last one he revised, is the most useful for assessing his contribution. We find him here claiming with pride and typical overconfidence to have treated the architecture of India in a "quasi-exhaustive" manner, and what is more, to have presented a distinctive view of the gen-

eral principles that had governed its historical development.[10]

Fergusson refers to India, where he first began to think about the practice of architecture and monuments of the past, as "that great and most poetic region of the globe," where in his picturesque words "though old and decrepit, art still follows the same path that led it towards perfection in the days of its youth and vigour."[11] His approach to the monuments of India was direct: he handled buildings with the same intimacy as we would sculpture. As he watched the traditional architect and workmen constructing new temples at the Jaina pilgrimage center of Satrunjaya, he realized that they revealed to the "philosophical student of architectural art" not only the truth about Indian architecture but the "processes by which the cathedrals were produced in the Middle Ages" in Europe.[12] This immediate involvement with buildings led inevitably to work of the most intense kind among the ruins, where he endlessly pondered their mysteries until "I could read in the chisel marks on the stone the ideas that guided the artist in his design, till I could put myself by his side, and identify myself with him through his work."[13] Such passionate dedication was bound to produce fine work.

As a result of this profound experience and rigorous speculation, Fergusson, in his somewhat grandiose

manner, divided all architecture into what he called the True styles and the Copying or Imitative styles. The True styles — to which belonged Egyptian, Classical, Chinese, Medieval, and of course Indian architecture (see figure 1) — were arranged "solely for the purpose of meeting in the most direct manner, the wants of those for whom they were designed; and the ornamentation that was applied to them either grew naturally out of their construction, or such as was best suited to express the uses or objects to which the building was applied." Imitative styles, by contrast, Fergusson considered thoughtless copies, in which the "element of truthfulness is altogether wanting," so that architecture is degraded from "its high position of a quasi-natural production to that of mere imitative art." To this category Fergusson brashly assigned all European architecture after 1500, including the architecture of his own Victorian times.[14]

Fergusson's argument is full of difficulties and now largely overtaken, but it is important for us to recognize the "original genius," as Heinrich Schliemann characterized it,[15] which allowed Fergusson to see clearly the basic qualities of Indian architecture in spite of the long history of general contempt in which it and Indian art in general were held in Europe in his time. He was not deflected by the sumptuousness of the material, so disturbingly barbaric to many Europeans. Rather for him

Indian temples showed no lack of respect for the nature of the materials, and no disregard of function as he understood it, even though he was never fully aware of that function beyond the obvious, and never indicated any interest in understanding its true spiritual significance.

Be that as it may, what Fergusson did was to establish, as a "philosophical student of architectural art" (which is the way he liked to think of himself), the significance of Indian architecture as a subject worthy of study, and he then proceeded to study it. He insisted on the validity, as a discipline, of what we now call art history. To Fergusson, thus, the evidence yielded by the analysis of a work of architecture necessarily took precedence over that provided, let us say, by history or ethnography. In fact it was his unhesitating belief, particularly with regard to India, that it was architecture that illustrated ethnography, fixed the ever-varying forms of religion, and reconstructed history. Even language and literature could not do as much, for architecture "is more distinct, it never shifts its locality, and it does not change with time and permits us to know exactly the religion, the art and the civilization of the people who built it. Distinct historical assertions have to be put aside whenever evidence of style is found to contradict them . . . unless good cause can be shown

to the contrary."[16] Here, Fergusson could not have been clearer.

In taking the position he did, in insisting on studying a work of art in its own right as well as the logic of the discipline of which it forms a part, Fergusson adopted a refreshing approach quite in advance of his time as far as the study of Indian art was concerned. True, he was sometimes led into error by underestimating the value of ancillary evidence, but it is a remarkable testimony to the soundness of his thought that the broad sequence he established for the evolution of Indian architecture has largely stood the test of time. Perhaps because of the general brilliance of his scheme, it is a matter of some puzzlement to me why Fergusson so blithely, and with uncharacteristic thoughtlessness, classified the works of Indian architecture on a denominational basis: "Buddhist," "Hindu," "Jaina," and "Muhammadan." This is one of the few instances where he may be found to have slipped into currently accepted modes of thought without having examined them vigorously; but one cannot blame him too much for this. This easy communalistic classification, honored by time if nothing else, still survives, being freely and loosely used both in scholarship and in common parlance without much thought to its implications. I myself have the distinction of belonging to an institution which has a curator

of Hindu and Muslim painting, though the designation, I understand, is about to be changed. It is really a credit to Fergusson's acuity that he was somewhat uncomfortable with his own categories, remarking, that "there is not only one Hindu and one Muhammadan style in India, but several species of each class, that these occupy well defined local provinces, and belong each to ascertained ethnological divisions of the people."[17] It is heartening, thus, that he speaks in terms of regional categories as well, though in the guise of a racial nomenclature: thus the Dravidian, by which he meant the style of south India, the Indo-Aryan or Northern style, and even a Himalayan style. He also used a dynastic name, Chalukyan, but was himself unhappy with it, characterizing it as a temporary appellation for a regional style existing in what was the yet unexplored borderland between the Northern style and the Dravidian style, and which is now identified as the modern state of Karnatak.[18] Fergusson, thus, contrary to appearances, was not entirely unmindful of a suitable classificatory system, turning over in his mind the implications of racial, religious, regional, and dynastic groupings, all of which have been used to the present day. Even if he did not pursue the matter, he at least provided, on this subject as on others, a basis for intellectual discussion of an important problem that was not

taken up till much later and that still remains to be sorted out.

What Fergusson achieved, in the context of the scholarly traditions of his time, was really quite amazing. For when he began, all was, in his own words, "darkness and uncertainty, and there is scarcely a work on architecture published or lecture read, which does not commence by a comparison between the styles of India and Egypt, and after pointing out a similarity which seems to be an established point of faith in Europe, though in reality no two styles are more discordant, the author generally proceeds to doubt which is the more ancient of the two, and in most cases ascribes the palm of antiquity to the Indian as the prototype."[19] By the time Fergusson completed his work, about forty years later, a large number of monuments had been surveyed and described and a broad stylistic development established. Problems still unsolved had been opened up to further investigation, and future lines of research indicated. The main weakness of these studies was their failure to follow up the line of inquiry initiated by Ram Raz, namely, a comparative study of the texts and the monuments, but then Fergusson was on his own admission ignorant of Indian languages and thus not qualified to pursue this kind of work. Suffice it to say that because of Fergusson's

labors the study of Indian architecture began to function almost at its inception at a much higher level than research on any other branch of Indian art, though the pace, unfortunately, was not maintained.

About the same time that Fergusson was setting out on his voyage of architectural discovery, Alexander Cunningham (see figure 2), a military officer of the Bengal Engineers, later to become a major-general, also arrived in India. Cunningham, too, came under the strong influence of Prinsep, and he embarked upon a career that made him one of the pioneers of Indian archaeology. The Archaeological Survey of India, which continues to do distinguished service, was established in 1865 largely through Cunningham's efforts after he had retired from the army, and the study of Indian antiquities was finally removed from the domain of individual entrepreneurship and provided with an institutional umbrella. Partly as a result of this and because he continued to believe that "architectural remains naturally form the most prominent branch of archaeology,"[20] Cunningham was able to expand systematically on the explorations undertaken by Fergusson. He discovered and described a large number of temples all over north India, particularly in Kashmir, Madhya Pradesh, and Rajasthan; and in this aspect of his work he did yeoman service. His own particular contribution to architectural history was to trace the

development of Gupta architecture. Here he postulated, no doubt under the influence of Darwinian laws of evolution which were beginning to affect all branches of study, a development from the flat-roofed temple to one with a spire, a theory that held the field until recent times.[21]

Cunningham's main achievement was an expansion of the corpus of monuments. Of the methodology so brilliantly built up by Fergusson, he was somewhat skeptical. He insisted, for example, that with regard to chronology it was the evidence of the inscriptions that deserved the principle attention, not the evidence of architectural style which was but of a corroborative nature. This assertion was a clear reversal of the priorities of Fergusson.[22] Judged in the light of Cunningham's own career — he was always at heart a numismatic historian — this is hardly surprising. As a practical matter, however, Cunningham ended by accepting Fergusson's chronology of medieval architecture, remarking, if somewhat reluctantly, that in this instance "the process of deduction, based on actual dates," was acceptable.[23] As we know, Fergusson too was always willing to modify his conclusions based on style if there was good cause to the contrary. Nevertheless, the lines were drawn, and we have here a basic difference of approach that persists to our time. To Cunningham, the evidence of style was *not* of primary

importance, architecture being but an illustration of history, while to Fergusson, it was the opposite, architecture serving to illumine history. One need hardly wonder, thus, at Cunningham's reluctance to visit temples that reportedly lacked inscriptions, for in his mind it was the evidence provided by inscriptions that was most meaningful for the understanding of history. This attitude was responsible for the somewhat curious publications of later times in which the sculpture, though described, was not reproduced, while the inscriptions it carried were.[24] Nothing could be more symptomatic of the belief that a few written words could tell more about the past of India than entire monuments.

While Fergusson had paid some attention to the problem of proper classification, he continued to use the rubrics "Hindu," "Buddhist," "Jaina," and "Muhammadan," terms which are actually misleading because they suggest that there are fundamental differences among the art of the three religions and that the nature of the religions affects the quality of the art, an argument for which there is not, in my opinion, any significant evidence. The Jaina temple at Osia is hardly to be distinguished from the Hindu temple at Jagat except of the grounds of provenance and style (see figure 3). Cunningham, to his credit, emphasized a classification based on time rather than religion, though

he gave his periods somewhat fanciful names such as "Indo-Grecian," "Indo-Scythian," "Indo-Sassanian," clearly emphasizing what in his eyes was the derivative nature of Indian artistic achievement.[25] This was a deep-seated and perennial prejudice, already entrenched in the work of Fergusson,[26] understandable in the context of the nineteenth century, and subjected to heated controversies in the early twentieth. Untenable attitudes, strengthened by repetition, die hard, and this one never ceases to surface, even now.

Cunningham, though a reluctant admirer of Fergusson, was hardly a follower; but James Burgess, part of whose career coincided with that of Cunningham, whom he succeeded as director general of the Archaeological Survey, certainly was a Fergusson disciple, almost tiresomely so. Though he lacked Fergusson's inclination for "philosophical enquiry," Burgess filled in his mentor's broad outlines by providing rather thoroughly researched documentation, far superior to Cunningham's largely unconnected and episodic presentations. Burgess' ideal was a carefully arranged and analytical study "with full and accurate descriptions of the monuments indicating their relations to whatever is already known, their relative chronological positions, and, generally, to supply the information available in a form so far final that both historical and art students can with confidence apply to the reports for the light they

throw on their researches.''[27] This ideal was largely
realized in a series of reports covering western, and to
some extent, southern India, published in the last
quarter of the nineteenth century. Thus, a well-
thought-out methodology, relying heavily on Fergus-
son's system and strengthened by an expanded corpus
and greater use of epigraphical sources, though largely
lacking Fergusson's visual acuity, had now matured.

This system dominated architectural research in
India for a long time, and continues to influence it
today. It was not a bad system, rather an excellent one
so far as it went; but it did not go far enough. Burgess,
for example, continued the simplistic communal classi-
fication "Hindu," "Buddhist," and "Jaina," though he
should have known better, and he continued to ignore
Indian sources, such as the texts and those traditional
architects who understood both the texts and the craft,
though many of them worked right under his nose at
the pilgrimage center of Satrunjaya in Gujarat. When
Henry Cousens, his able assistant, attempted to use
Indian architectural terms in the manner of Ram Raz,
so as to focus more precisely on the detailed structure of
a temple, something that was difficult to accomplish
with an ill-fitting European terminology, Burgess re-
fused to countenance the effort on the curious ground
that "few of these terms are to be found in our lexicons,
and their precise forms can hardly be controlled out of
India."[28] The study of Indian architecture, in other

words, was for Burgess really for non-Indians, by non-Indians. Certainly, Indian architecture was not being thought of in terms of the people for whom it was made. There was not much future in attitudes like this. Fergusson's system, without his innovative mind, had become a prisoner of its own framework. It was refusing to grow, spurning contacts with new developments, destined to stagnate into a backwater.

Fergusson, Cunningham, and Burgess did attempt in varying degrees to establish the chronology of Indian temple architecture, but they made little actual progress. Their efforts did not meet with the approval of the French scholar Gabriel Jouveau-Dubreuil, who, while granting that good photographs and descriptions were important, argued that there was a difference between mere description and an analytical study involving comparison and systematic classification possibly leading to the discovery of the laws according to which the monuments had been built. It was important, he believed, to write what he called "l'anatomie et la paléontologie des edifices"[29] (shades of Darwin, once again). This he proceeded to do in an extremely influential work in two volumes, *Archéologie du sud de l'Inde,* published in 1914. The first volume confined itself to the architecture of the Tamil-speaking country, what he called Dravidian architecture; the second concerned sculpture, which I will deal with in Chapter 2.

Basically, the method Jouveau-Dubreuil adopted for

the discovery of his architectural laws was a compara-
tive study of ornament, a technique that was later
greatly developed by another group of French scholars,
led by Philippe Stern, for the study of Indian sculp-
ture. Jouveau-Dubreuil first isolated a set of signifi-
cant architectural parts with their decorative patterns,
which constituted what he called the orders of south
Indian architecture.[30] This he was able to do by care-
fully questioning the traditional architects who were
building a temple in Cuddalore. By next scrutinizing
temples that were securely datable on the basis of their
inscriptions, he was able to specify the precise group of
motifs that characterized each of the temple styles.
This type of careful comparative work enabled him
to classify all south Indian architecture on a chronolog-
ical basis. This task was simplified by his success in
establishing that as far as the Tamil country was con-
cerned there was only one style in each period. He
named these periods largely after dynasties: Pallava,
lasting from 600–850; Cola, 850–1100; Pāṇḍya,
1100–1350; Vijayanagara, 1350–1600; and lastly, the
Madurā style, which lasted from A.D. 1600 to his own
time.[31] The changes in style from one period to an-
other occurred by gradual evolution, and according to
Jouveau-Dubreuil they were comparable to the devel-
opment of the human brain from the earliest simian
phase to its fully developed form. To him, thus, there

was as much difference between the temple at Madura and the shrine at Tanjore as between Cro-Magnon man and man as we know him now.[32] A strong case of Darwinitis! Thomas Huxley, as early as 1859, was already complaining of the "creeping Darwinismus" he had observed in the lectures of Fergusson.[33] I wonder what he would have had to say about Jouveau-Dubreuil.

Nonetheless, just as with Fergusson, these idiosyncrasies cannot permit us to overlook the enormous contribution which Jouveau-Dubreuil made to the study of Indian architecture. By acquiring a direct knowledge of the monuments and an understanding of the living architectural tradition, and by subjecting these to a logical and systematic (albeit somewhat limited) methodology, Jouveau-Dubreuil was able to establish a history of south Indian architecture that excelled previous achievement. He often corrected the chronological errors of his predecessors, at times by over six hundred years.[34] His work is even more admirable if we remember that the dynastic classification he uses is only nominally so, and that dynastic names are little more than convenient labels for given periods of time. It was not Jouveau-Dubreuil's intention to suggest that the dynasty which happened to be ruling was in any intimate way involved in the evolution of style in the sense in which these labels came to be used in a

later time. It often happens that terms first employed in all innocence for convenience take on a meaning of their own, and thus begin imperceptibly to distort our thinking. A correct nomenclature helps greatly in keeping us on track.

Jouveau-Dubreuil's basic stylistic and chronological conclusions still stand. His approach was influential and has remained, consciously or unconsciously, the basis of much thinking by art historians, not only in France, where a similar method was applied to the study of Southeast Asian art, but also in India, where his ideas affected the scholarship of a whole generation, notably F. H. Gravely, T. N. Ramachandran, and C. Sivaramamurti. But more of this later. Nevertheless, a great objection to Jouveau-Dubreuil's method, however refined and complex it may have later become, was its exclusive reliance on ornamental motifs in tracing the evolution of a style. He disregarded qualities of inner form in his persistent concern for surface motifs. His approach was that of an archaeologist studying his artifacts rather than that of an art historian for whom style should be "a system of forms with quality and meaningful expression."[35] Carried to its logical extreme, Jouveau-Dubreuil's method would give us no way of distinguishing an ancient building from a modern copy.

All these aspects of Jouveau-Dubreuil's work are

understandable, however much one may differ from him. But what is astonishing, even if a natural consequence of his particular point of view, is his assertion that his work was independent of aesthetic consideration. Appreciation of beauty, he says, is a matter of taste and, to translate his own words, "we do not pretend to be indulging in criticism of art."[36] Architecture and iconography, according to him, would be interesting whatever opinion one had of the aesthetic sense of the Hindus — very much, I suppose, in the sense that a puzzle is interesting. To accept this view, I am afraid, would be to confine ourselves, once again in Jouveau-Dubreuil's own words, to "the anatomy and paleontology" of a work of art, to exclude from purview its inner life and spirit, which alone give it a reason for being.

However important the contributions of these pioneers, we have seen that they were hardly free from the standard prejudices of their time, notably a constant assertion of the superiority of Greece and Europe and the inferiority of India. A corollary to this mode of thought was the assignment of foreign origins to anything and everything in India that had the appearance of being worthwhile. This aspect of their work could hardly escape challenge. Add to it the condescending tone, sometimes degenerating into intemperate and racist attack — the most notorious example being Fer-

gusson's on Raja Rajendralala Mitra, who had the te-
merity to disagree with him — and we have all the
elements of a heated controversy in the making.[37]

This controversy was not long in coming. It was
launched with a vigorous frontal attack on the scholar-
ship of Fergusson and Burgess, not by an Indian but by a
sensitive English artist, Ernest Binfield Havell (see fig-
ure 4), principal of the Calcutta School of Art, in a
series of works on Indian architecture, the first of them
published in 1908. The thrust of Havell's criticism
was that, by failing to approach Indian architecture
from the Indian point of view, Fergusson came up with
little more than "arbitrary academic ideas of style."[38]
More specifically, Havell rejected the sectarian division
of styles and the persistent habit, as he called it, of ever
looking for foreign influences, as well as the total
failure to read the inner meaning of the temple. With
all his faults, conceded Havell, Fergusson had genius,
while his followers had none, so that the study of
architecture had made no progress and stood right
where Fergusson had left it.[39] All this is true enough
and well taken, and the vigor of the polemic success-
fully broke the Fergussonian grip on Indian architec-
tural studies. This break indeed had become necessary
in the interest of further progress, even as one admits
that Havell's writing lacked the scholarly discipline
that would have made his own contributions accept-

able. His was more an emotional rather than an intellectual approach, and several of his ideas were so curious and fanciful that they only detracted from the more significant aspects of his work.

Many of the shortcomings of early scholarship were largely overcome in the work of Ananda Coomaraswamy, who in the course of an illustrious career was responsible for reestablishing the study of Indian art, whether architecture, sculpture, or painting, on a new basis. Among the weakness of his predecessors that Coomaraswamy corrected were the failure to explore Indian sources and to consider the inner meaning of the monuments; the flawed studies of architectural texts without reference to the surviving monuments or traditional architects (of the type carried out, for example, by P. K. Acharya from 1918 onward);[40] the study of the style conceived only in terms of the development of ornamental motifs; and the study of the symbolism of the Indian temple without a grounding in architectural or religious history. His first major contribution to the subject interpreted a number of unclear Indian architectural terms in a comprehensive manner, using linguistic and architectural skills to lay bare not only the technical meaning of a word but also its interpretation at a deeper level of symbolic reference.[41] In a series of articles on early Indian architecture he displayed his mastery of archaeological techniques, and also a knowledge of

both literary texts and sculptural reliefs to recreate convincingly the architecture of ancient Indian cities with their walls, gate-houses, temples, houses, windows, and other features, pointing out their relevance for the understanding of the forms of later architecture. In the process, he also convincingly established the origins of the spire of a north Indian temple, a problem that had hitherto excited interest but evaded solution.[42]

Having brought the basic facts both archaeological and literary under control, Coomaraswamy proceeded to investigate the inner meaning of the architectural form itself.[43] The origins of a structural form, he argued, could be studied from either a technical or a logical point of view, either as fulfilling a function or as expressing a meaning, the function and significance coinciding in the form of what he called traditional and what Fergusson would probably have called True architecture. Coomaraswamy rejected the view that symbolic meanings are "read into" the "facts" which originally had no meaning but only a physical efficiency; he considered this view the imposition of the modern mentality onto that of the Indian artificer. He thus interpreted the Hindu temple not only as a building providing shelter for the image and the worshippers but also as the image of the cosmos, the house of God and also his body, representing in its parts the

drama of disintegration and reintegration which is the essential theme of Indian myth and its ritual enactment in the sacrifice. Coomaraswamy thus carried the study of the temple beyond its investigation in place and time to its inner meaning, to its very reason for being, without which, he felt, the study of the architecture was seriously incomplete.

Coomaraswamy thus represents a new orientation in art historical research, an orientation emphasizing an inquiry into the values actually attached to the art by those for whom it was made, pleading for the adoption of what the brilliant French scholar Paul Mus called comparative religious archaeology.[44] Coomaraswamy transcended that concept of the history of art which held it to be primarily concerned with unraveling influences — a view that had plagued Indian art historical writing from its inception — or which devoted itself largely to the study of the development of form and its attribution to a particular artist, period, or place. Coomaraswamy's work thus gave a new and meaningful dimension to the study of Indian architecture, one which went far beyond that of Fergusson and his followers and which was only intuitively felt by Havell.

The next landmark in the study of Indian architecture was the appearance in 1946 of Stella Kramrisch's monumental book *The Hindu Temple*,[45] which remains the outstanding work on the meaning and symbolism

of the sacred building. Kramrisch enlarged and considerably expanded on the work of Coomaraswamy and Mus, and made copious use not only of religious texts but also of the architectural canons, increasing numbers of which continued to be discovered and published in India. Her knowledge, both sensitive and profound, breathes a new life into our understanding of the monuments she studies with great depth and perception.

There is a relatively new kind of research of which people outside India are not as fully aware as they should be, for it is mostly written in Indian languages. I am referring to interpretative studies of traditional architectural texts produced by practicing architects of ancient building traditions who have finally cast off the veil of secrecy they were enjoined to throw around their art. Of these writers, the most eminent was Prabhashankar, belonging to the great Sompura cast of architects who had built temples in western India for centuries and who counted as their own famous scholar-architects like Maṇḍana who served Mahārāṇā Kumbhā of Mewar in the mid-fifteenth century. Prabhashankar was not only a leading architect, responsible for building a series of temples in the time-honored manner all over India, including the immense structure dedicated to Śiva at Somnath; he was also a scholar of the sacred canons, a keen student of the ruins of the past, and, fortunately, a person sympathetic to

the problems of modern scholarship. Motivated initially by a desire to help his fellow architects, whose knowledge of ancient traditions and whose technical ability was rapidly declining, he decided to translate into the Gujarati language and to interpret for their benefit the various texts in his possession. Though the work was begun around 1916 and known to an inner circle of friends, it remained in manuscript form until the 1960s when he was persuaded to put some of it into print. The appearance of these studies, notably the *Dīpārṇava* in 1960, has strongly affected the study of Indian architecture, aiding immeasurably our understanding of the various parts of a temple and permitting the development of a comprehensive indigenous vocabulary rooted in the texts, the standardized and increasingly widespread use of which gives recent Indian scholarship a clarity and precision hitherto unknown. This has also imparted direction to stylistic analysis and has begun to yield valuable clues for understanding structural origin and symbolic meaning. The technical vocabulary of the monuments, as a result of all this effort, is now fairly clear, which is tantamount to declaring that the basic grammar of Indian architectural forms has been set out. A new phase can be said to have begun in the analysis and understanding of Indian architecture.

Some idea of the current state of affairs can be ob-

tained by taking note of the work of M. A. Dhaky,
who, along with K. R. Srinivasan and Krishna Deva,
has opened up new paths to students. Dhaky, actively
cooperating with Prabhashankar Sompura, has played
an important part in the publication of texts, to the
interpretation and critical assessment of which he has
brought an intimate acquaintance with the monu-
ments. Many of his studies are characterized by a
felicitous use of traditional architectural texts to throw
light on ancient temples; his fine monograph on the
ceilings of Gujarat temples is an early example,[46] in
which he uses the written word to devise a classification
and a detailed elucidation of some of the most complex
and exquisite examples of the architect's craft. The
methodology he has been developing is most clearly
reflected in a brilliant pioneering study[47] in which he
divides the temples of Gujarat and Rajasthan into re-
gional categories and, consciously avoiding a dynastic
nomenclature, gives them appropriate geographical
names. He then proceeds to interpret the architecture
in terms of the growth and interaction of these styles,
throwing a flood of light on the architectural process
itself, rather than on its historical premises. Dhaky has
for the last several years been the principal moving
force behind an encyclopedic work on Indian temple
architecture which is being prepared at the Center for
Art and Archaeology of the American Institute of In-
dian Studies in Varanasi, India. I myself had the privi-

lege of being associated with its establishment and early growth. Its publication will provide rich and detailed information that will be of immeasurable help to future scholars.

I have tried to convey some idea of the progress of architectural studies, the methods used to define and solve problems, the nature of the shortcomings and also of the great advances made. Though studies got off to a flying start with Fergusson, the failure for some time to pursue the evidence of the indigenous architectural canon and that of the living tradition was certainly inhibiting. The inability to think of a temple in terms of those for whom it was made was overcome in the work of Coomaraswamy and Kramrisch, and recent work has placed the study on the threshold of new and important achievements. The texts, once shunned as inexplicable, are rapidly yielding their secrets; a careful and well-reasoned discussion on the basic systems of classification is occurring; and innovative methodologies are being put into practice. The danger here is not too little innovation but too much intoxicating speculation with little reference to the material or into which materials are forced to fit. Chronological elucidation, so basic to any study of art, continues to progress, and is carefully based on style, epigraphical evidence, history, and other forms of information as well; though to the historian of Indian art, it seems to me, style will always be the most important criterion.

TWO

Sculpture

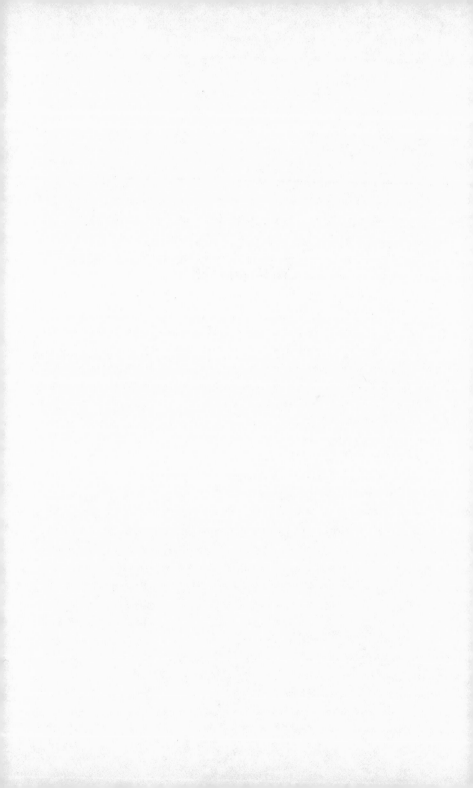

The scholarship of Indian architecture, as I pointed out in Chapter 1, got off to a flying start in the nineteenth century with the redoubtable James Fergusson showing the way. It would be the normal expectation that something similar would have happened in studies of sculpture — Jouveau-Dubreuil even asserted that Indian architecture is really nothing but a pile of carved stones[1] — but it just did not work out that way. The reasons for this are not far to seek. Fergusson, Cunningham, Burgess — the three savants whose work so dominated nineteenth-century scholarship — were just not able to cope with problems of sculpture as art; their psyches were steeped in a Victorian repugnance for all heathenish idolatry, a repugnance the roots of which extended back into the Middle Ages in Europe.[2] With the possible exception of Fergusson, they did not care for sculpture, and if it sparked their interest at all it was for its ability to illustrate the history and culture of India.

I am somewhat disappointed at Fergusson's lack of interest. His keen mind and his obvious devotion to Indian architecture might have been expected to produce at least some provocative thoughts on sculpture; and we do get a very few; but these are hardly enough. For example, Fergusson admired the work at Bharhut (see figure 5), characterizing it as thoroughly original and without a trace of foreign influence. Like works of true architecture, he remarked astutely, the figures "though very different from our standard of beauty and grace, are truthful to nature, and where grouped together, combine to express the action intended with singular felicity."[3] Though he believed the sculpture at Sanchi (see figure 6) had already begun to decline, he also praised its originality, saying that it was "difficult to assign it to any exact position in comparison to the arts of the Western world." One may wonder why he thought work at Sanchi to be inferior to that at Bharhut; it is well in keeping with a pet theory of his whereby "the history of art in India was written in decay." He devoted half a book to Amaravati, but with regard to the sculptures there, he was content to note that they were "extremely remarkable from an artistic point of view."[4] Even this general assessment caused him much discomfort, for it was also apparent to him that the sculptures of Amaravati were later than those of Bharhut and Sanchi, and should therefore, according

to his theory of decay, be that much the worse. But this they were not. By way of explanation, he did what was to be done by many others after him: he invoked the intervention of Greek influence. It was Graeco-Bactrian art, which flourished on the north-western borders of India, that made the difference, never mind the time lag of three hundred years that separated the two. Classical influence must have survived all that time, he theorized, though there was no proof of it.[5] The clarity of thought that characterizes Fergusson's work on styles of architecture is nowhere to be found, I am afraid, in his remarks on sculpture.

Fergusson showed a real interest in sculpture only to the extent that it could reveal something about life in ancient India. Witness the lengthy title to his book: *Tree and Serpent Worship; or Illustrations of Mythology and Art in India in the First and Fourth Centuries after Christ from the Sculpture of the Buddhist Topes at Sanchi and Amaravati.* That Indian sculpture displayed a sense of inherent style from which a chronological sequence could be ascertained was something that does not even seem to have occurred to him. The idea that one could date a building on the differences of sculptural style he dismissed as being of frail foundation. "The human form is not progressive," he confidently asserted, "and it depends very much on the skill of the sculptor and local circumstances whether a nude figure of the first or

fourth century differs from one in the eleventh or fourteenth." "I have," he continued, "examples of both ages so similar that it would puzzle most people to say to which age they belonged, and no satisfactory conclusion, can, I conceive, be drawn from such data."[6] In spite of all his love for Indian architecture, he simply had no eye for sculpture.

General Cunningham was no better; if anything a little worse. One combs his voluminous work in vain for any illuminating remarks on the topic of sculpture. When he speaks of the Maurya lion capital at Sanchi, all he has to say is that "with its muscles and claws so accurately represented, it might well be placed in comparison with many specimens of Grecian art," from which premise he proceeds to draw the easy conclusion that Asoka actually employed a Greek artist.[7] This is just the kind of simpleminded remark of which his books are distressingly full. To Cunningham, too, sculpture's chief interest lay in its capacity to reveal something about the life and history of ancient India, so much so that the primary value of the sculptures of Bharhut was that they were inscribed with labels.[8] The inscribed label was all, the sculpture not very much. In the course of his explorations, Cunningham had discovered a wonderful image of the Buddha at Sravasti, dating from about the first century A.D., with an inscription saying that it had been dedicated by a

monk named Bala. Cunningham had the image re-
moved to Calcutta, where the authorities placed it in
the midst of a host of stuffed deer and antelopes. This,
Cunningham was to later complain, was quite unfortu-
nate, not because the sculpture deserved better but
because the inscription had been thereby concealed.[9]
All of Cunningham's considerable energies were di-
rected to extracting whatever information he could
from the sculptures about life in ancient India. For
example, the lovely Bhutesar Yakṣīs from Mathura
with the "unabashed assurance of their smirking nudi-
ties" allowed him to conclude, in a statement replete
with scholarly caution, that "at least certain classes of
women must have been in the usual habit of appearing
in public almost naked."[10] This feature of life in an-
cient India must have troubled greatly his Victorian
sensibilities.

James Burgess' understanding of sculpture was
equally limited. It is true that he did not accept Fer-
gusson's theory of constant decay; instead he reversed it
and asserted that the earlier the sculpture, the *less* rather
than more elegant and perfect its style in comparison
with the refinements to be seen at Amaravati in the
second century, which he described as probably the
most elaborate and artistic monument of its kind in
India. After Amaravati, "conventionalism began to set
in," and that is about the extent of what he has to say on

the subject.[11] It is well to remember that even this
rudimentary step was taken only in the 1880s. Bur-
gess' attempts at stylistic studies, like Cunningham's,
were extremely feeble. The skill and invention shown
by the Indian sculptor in executing ornament Burgess
characterized as simply astonishing but "in the repre-
sentation of the human form, the head and trunk are
often passable but the leg and arms are generally weak
and wanting in muscle. This defect has been com-
mented on by different authors and variously ascribed
to the physical characteristics of the race and to the
overlaying of limbs with richly carved orna-
ments . . . Art for itself was not a pursuit that at-
tracted the mind of the Hindu and his sculpture was too
conventional to be true to ideal types in nature."[12] If
Indian art was any use at all it was, once again, for
throwing light on ancient life, particularly religion.
Here Burgess echoed Fergusson on the surpassing im-
portance of artistic evidence: "The sculpture on any
structure is . . . more truly representative than any
shastra of the exact form of Brahmanic belief held by
the builders of the structure it ornaments," but in and of
itself it is of very little value, for "high art has never
been with the Hindu, as with the Hellenic race, a felt
necessity for the representation of their divinities."[13]

This was the rather simple notion of Indian sculpture
held in the opening years of the twentieth century after

nearly fifty years of sustained study. Progress was indeed very slow, compared to what had been accomplished in the study of Indian architecture. Artistically, Indian sculpture was judged, on the whole, to be rather worthless, and if there was anything of value it was explained as the product of foreign influence. However extraordinary all this may sound now, it is understandable to some extent, for knowledge can be gained only in the mode of the knower, and to the knower of this period, Greece was the source of all art and civilization. Thus the great James Prinsep stated in 1838: "as long as the study of Indian antiquity confines itself to the illustration of Indian history it must be confessed that it possesses little attraction for the general student. But the moment any name or event turns up . . . offering a plausible point of connection between the legends of India and the rational histories of Greece or Rome, forthwith a speedy and spreading interest is excited."[14] In other words, Indian antiquities were of themselves not interesting, becoming so only when they could in some way be connected with the classical world. This attitude rapidly became what can only be called an obsession in the nineteenth-century scholarship of Indian art. It lay at the back of the curious theory that the high level of achievement at the very beginning of Indian art had been followed by constant decay, the best having been achieved during

the earlier period when India was supposedly under the influence of Greece. As the Grecian influence decreased with the passage of time so, supposedly, did the quality of art.

This theoretical bias became more strongly entrenched as the Gandhāra school and its Greek affiliations became better known, particularly through the comprehensive work of the gentle and scholarly Alfred Foucher. His *L'Art gréco-bouddhique du Gandhara,* the three volumes of which appeared in 1905, 1918, and 1923, and which was the very first work of its kind on any Indian school, is a landmark for the study of Indian sculpture. Foucher studied Gandhāra exhaustively and with great care, employing a broad-based method greatly in advance of that used by his predecessors, and one which became standard in India. He synthesized evidence gleaned from archaeology, epigraphy, numismatics, and art history, and he was the first to emphasize the importance of style. Faced with a vast mass of intractable sculpture, with hardly any dated examples, much of it also lacking any well-ascertained provenance, Foucher was quick to realize that the only hope for establishing a chronology was to have recourse to style. As far as reconstructing the chronology of Gandhāra art is concerned, he declared, the style is everything, the subject nothing, and the task can be accomplished only by faithfully remembering that the

way in which a sculpture is fashioned is infinitely more important than the subject that is being sculpted.[15] The importance of style for the study of Indian sculpture could not have been more clearly stated. True, Foucher's perceptions of what constituted style were fairly simple and somewhat subjective, but he did clearly announce its importance, and by concentrating on style he was able to spell out a broad line of development for all of Gandhāra art, something which at that period must have seemed impossible of achievement. We may differ with Foucher's understanding, but what he accomplished was truly remarkable. A new methodology had been put into effect with the help of which he was able to claim a Greek origin for the Buddha image itself.

The preference for the Gandhāra school was natural enough in European scholars; they could hardly be faulted for liking an art that was closer to their range of visual experience. I recalled in the Introduction that Sir Aurel Stein had noted with pleasure "the entire absence of those many-headed and many-armed monstrosities" in the caves of Tun Huang. He went on to say, "And still more reassuring was it to see everywhere the faithful continuance of the sculptural traditions as developed by Graeco-Buddhist art."[16] If Sir Aurel Stein was reassured in the wastes of Central Asia by memories of Greece, we are pleased for him. The

trouble comes when a personal preference of this type begins to color and prejudice scholarship. And that it indeed began to do so is fairly obvious. Sir John Marshall, director general of the Archaeological Survey of India through much of the first half of the twentieth century, though he wrote with far more information and experience than Cunningham, followed him in ascribing the Maurya lions to Hellenistic influence and a foreign artist. The explanation was entirely speculative and tortuous, positing an art of mixed Iranian and Hellenistic spirit in Bactria as the possible source from which the artist drew his inspiration. This unsound and unapologetic argument, for which there was at the time very little evidence, is the natural product of an inability to conceive of any real artistic capability among the Indians—even the Sarnath capital, Marshall said in an aside, is "by no means a masterpiece." What follows is even more astounding. Bharhut itself, or at least the sculptures of "superior" execution at that site, he declared to be under the influence of workmen from northwest India, "where thanks to Western teaching . . . the formative arts were then in a more advanced state"; and the more developed style of Sanchi was also due to the deepening of these extraneous influences.[17] Again, the implication is that any development by the Indians of themselves was not possible; they could achieve little without foreign help. Atti-

tudes of this type could only have a disastrous effect on scholarship, and in the case of Marshall they did.

This prejudiced view of the development of Indian sculpture prompted the same vigorous reaction and by the same people as in architectural studies. E. B. Havell's polemic against the archaeologists, as he preferred to call earlier scholars,[18] was once again very lively and fired in a broad salvo against every cherished assumption. Without fear of consequences, he condemned the Gandhāra school as being an effete and inferior style of only marginal importance to the history of Indian art, and said that there was no excuse for judging Indian art by the standards of anatomical realism one applied to classical art. What was truly representative of the Buddha ideal was not the simpering creation of Gandhāra, but the image of the Buddha as the great Yogī, beyond pleasure and pain, to be seen in non-Gandhāran sculptures inspired by the Indian genius.[19] In biting attacks like this Havell was no doubt continuing to respond to the likes of the venerable Sir George Birdwood, a man of great common sense whose love for traditional India was unbounded but who was equally convinced that "the monstrous shapes of the Puranic deities are unsuitable for the higher forms of artistic representation." At the end of a lecture given by Havell as early as 1910, Birdwood had most dogmatically asserted that the Buddha image, "by its immemo-

rial fixed pose, is nothing more than an uninspired brazen image, vacuously squinting down its nose to its thumbs, knees and toes. A boiled suet pudding would serve equally well as a symbol of passionate purity and serenity of soul."[20] This startling statement brought about a strong protest by a group of leading artists, critics, and students of art in a famous letter to the *Times* of London defending the art of India as a "lofty and adequate expression of the religious emotion of the people and of their deepest thoughts on the subject of the divine."[21]

A scholarly offshoot of all this was the intensified controversy on the Greek or Indian origin of the Buddha image, a controversy that found its most elegant expression in the learned exchange between Coomaraswamy and Foucher and that finally culminated in Coomaraswamy's splendidly argued contribution to the *Art Bulletin* of 1927. Here, Coomaraswamy demonstrated with great skill that it was really a question of two separate developments, one that took place in Gandhāra, the other at Mathura. The Mathura image was a natural stylistic development from a whole series of images of Yakṣas which spanned the preceding period of three hundred years. We know images of this type from the Maurya period: firmly grounded and robust in appearance, one hand at the waist holding a bag, the other raised to the shoulder and often holding a

fly-whisk. This tradition yielded, when the need arose, the earliest Buddha images, notably the great statue dedicated by the monk Bala in the third year of Kaniṣka (A.D. 81), which preserve many of the features of the earlier Yakṣa images and share with them a feeling of weight and power. They are, however, garbed in monastic dress and display gestures appropriate to the Buddha; but in spirit they are really Yakṣas clothed in monks' apparel. These powerful images took on in the course of time the introspective, meditative, and spiritual aspect characteristic of the style of the Gupta period, the whole development being quite free of Gandhāra influence. The psychology of the Buddha image itself, Coomaraswamy argued, that of the teacher absorbed in *nirvāṇa,* was also deeply rooted in Indian tradition, so that the Gandhāra Buddha, even if developed independently of Mathura, must of necessity be indebted to the same Indian tradition. Thus, it was not so much a question of the Gandhāra sculptor, to quote Coomaraswamy's very words, making "an Apollo into Buddha," as urged by Foucher and others, but of making a "Buddha into an Apollo."[22] The broad range of Coomaraswamy's argument, which I shall not repeat here, was used with such devastating effect that the theory of the Greek origin of the Buddha image and the problem of foreign influence on Indian art receded rapidly into proper perspective, though not

quite into oblivion. Hermann Goetz, in an article published in 1959, developed a somewhat far-fetched theory that the Guptas absorbed vast amounts of Roman influence and then concealed it deliberately for reasons of nationalistic pride, but this theory seems to have had very few takers. In yet another work, published as recently as the 1970s, the celebrated relief from Gadhwa, near Allahabad, is praised, rightly enough, "as a work of art unequalled in all of Indian sculpture." That note having been struck, it was inevitable for the author to be moved to speculate on foreign influence, if by nothing more than poses like that of a maiden holding a canopy rod, which, we are told, were unknown in earlier Indian sculpture and are suggestive of Western classical origin.[23] A whole chain of arguments may be seen here that seems to me to be of the same category, and as unconvincing, as those used by Marshall half a century earlier.

Aside from foreign influence, a major and much more useful concern of early writers on Indian sculpture was its subject matter. Thus Fergusson struggled valiantly with what he thought were representations of tree and serpent worship depicted in the sculptures of Sanchi and Amaravati, even as he lamented that he had to do the work without the necessary literary and language skills.[24] Cunningham's contributions were more substantial, aided as he was by an understanding

1. *The Ambikā Mātā temple at Jagat, Rajasthan; dated A.D. 961.*

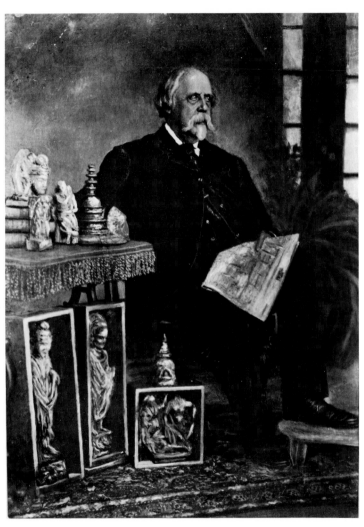

2. Alexander Cunningham (1814–1893).

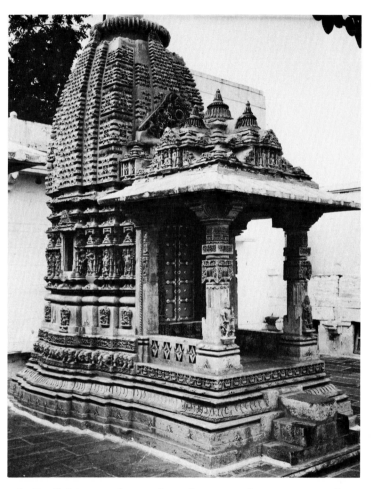

3. Small Jaina temple near the Mahāvīra temple at Osia, Rajasthan;
eleventh century A.D.

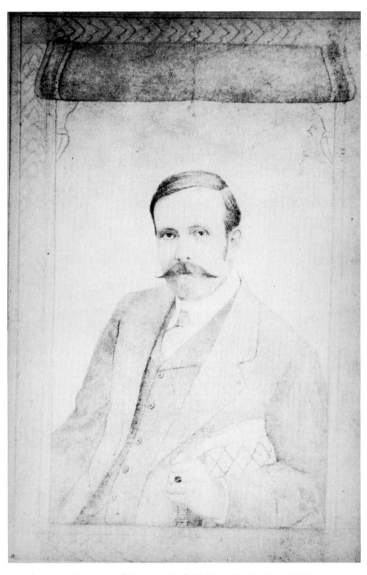

4. *Portrait of Ernest Binfield Havell (1861–1934)
by Abanindranath Tagore.*

5. *The dream of Māyā, the Buddha's mother. From Bharhut, Madhya Pradesh; middle of the second century A.D.*

6. *Landscape with lovers. From the toraṇa of the Great Stupa at Sanchi; middle of the first century* B.C.

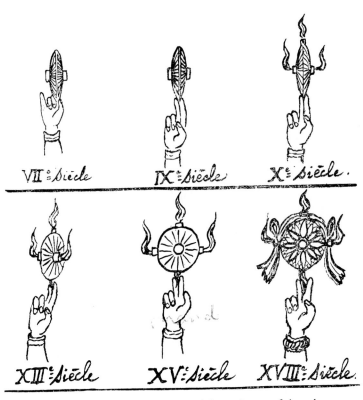

VII^e Siècle IX^e Siècle X^e Siècle.

XIII^e Siècle XV^e Siècle XVIII^e Siècle.

7. Jouveau-Dubreuil's depiction of the evolution of the cakra held by Viṣṇu.

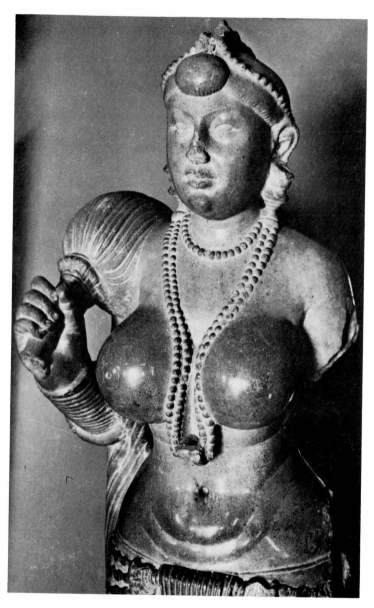

8. *Yakṣī. From Didarganj, Patna, Bihar; third century* B.C.

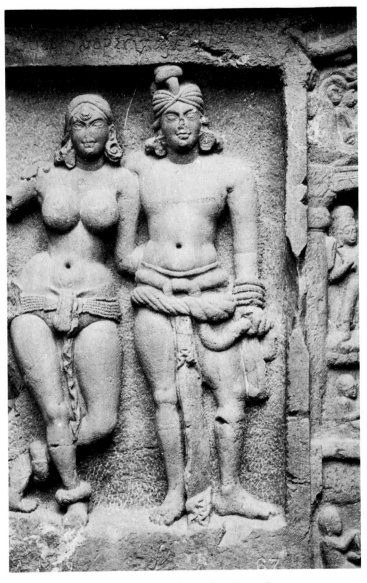

9. *Amorous couple. From Karle, Maharashtra; first century* B.C.

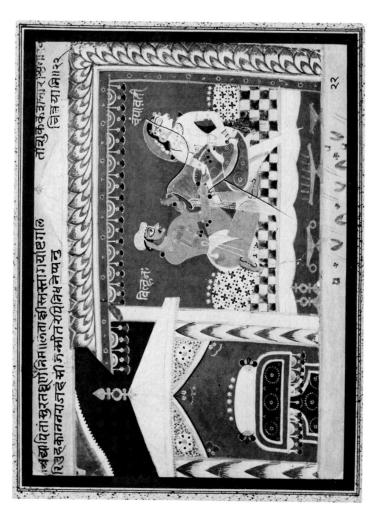

10. Miniature from a series illustrating the Caurapañcāśikā of Bilhaṇa; early sixteenth century A.D.

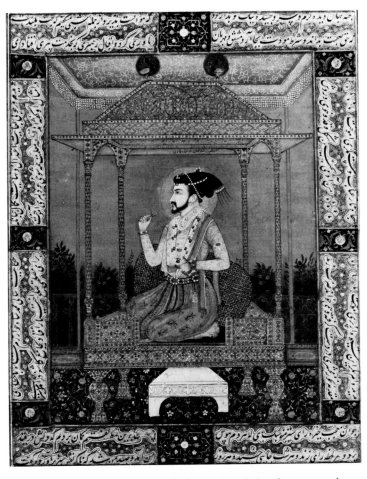

11. *Shāh Jahān on the peacock throne. Mughal style; nineteenth-century copy of a mid-seventeenth-century original.*

of the labeled sculptures at Bharhut; but the first serious iconographical work was Albert Grünwedel's pioneering *Buddhist Art in India,* which appeared in German in 1893 and in an English translation in 1901. Utilizing the work of earlier scholars, the monuments of ancient India, the increasing corpus of Gandhāran materials, a close familiarity with Buddhist religious texts, both Indian and Tibetan, and a comparative knowledge of Japanese Buddhist art, Grünwedel was able to lay a sound foundation for the understanding of the subject. This work was remarkably enlarged by Foucher, whose wide-ranging researches considerably clarified the subject, not only of Gandhāra art, but also of early Buddhist relief representations, particularly at Sanchi, the paintings of Ajanta, and the illustrations of palm-leaf manuscripts of the eastern Indian school.[25]

Hindu imagery, however, was yet to be tackled. Fergusson had already pointed out the necessity of work in which the information contained in the books would be "steadied and confirmed by what is built or carved, which alone can give precision and substance to what is written."[26] But the need remained largely unfilled, in spite of handbooks like Dowson's *Classical Dictionary of Hindu Mythology,* published in 1879. Finally in 1914 T. A. Gopinatha Rao, the Superintendent of Archaeology of Travancore State, published his monumental *Elements of Hindu Iconography,* based on

careful study of the Purāṇas, the Āgamas, the Tantras, and other texts, as well as the monuments, primarily of the south but also to some extent of north India. Though this four-volume work surpassed in comprehensiveness all previous writings on the subject, it could hardly be called complete. It did, however, give the initial impetus to the recording and description of images, which continues to the present day. There is hardly a learned journal dealing with Indian antiquity that does not frequently present an article on discoveries of new types of images, and the work itself is destined to continue for a long time to come. The kind of work initiated by Gopinatha Rao continued, and was extended to north India by B. C. Bhattacharya, who published important books on Brahmanic and Jaina iconography in 1921 and 1934. Other noteworthy contributions are Benoytosh Bhattacharya's *The Indian Buddhist Iconography* (1924) and N. K. Bhattasali's *Iconography of Buddhist and Brahmanical Sculptures in the Dacca Museum* (1929), the latter a thorough and painstaking iconographical study of the images of the eastern Indian school and the light they throw on the culture of Bengal.

The cataloging and identification of the countless number of divinities that crowd the Indian pantheon is hardly sufficient for a full understanding of iconography, though it must be admitted that without this basic

work any progress is impossible. Jitendranath Baner-
jea was among the first to place these studies in a firm
historical context, attempting to understand the evolu-
tion and development of iconographic types.[27] He
paid particular attention to the evidence provided by
coins and seals as well as to several previously un-
published texts, extending his work to include the
beginnings of Indian art. His careful and closely docu-
mented scholarship is of great importance to our under-
standing of the history of various kinds of images, and
throws a flood of light on the processes of their
growth. His pioneering approach was followed by
others, the most notable being a series of superb studies
published from 1948 onward by the eminent French
scholar M.-T. de Mallmann, that advanced our knowl-
edge of Buddhist and Hindu iconography along similar
lines.

Coomaraswamy, who did not leave a single branch
of Indian art studies untouched, also worked in iconog-
raphy; but his contribution was of a somewhat different
order, for he was as much interested in the history of
iconographic form as with its inner meaning. Indian
art, he felt, was primarily not an art of representation
but of statement, and it was imperative, therefore, to
"speak in the first place of significance, in the second of
style."[28] Of significance he spoke with unparalleled
insight, and his contributions to the study of Indian

iconology remain unsurpassed. I earlier referred to the brilliant essay in which he associated the cults of the Yakṣas and their worship with the origin of the Buddha image. Further explanation of Yakṣa imagery appeared in his two volumes entitled *Yakṣas*,[29] works monumental in significance if not in size, along with a penetrating exploration of the central concepts of Indian iconography, everything illumined by his vast knowledge of art, religion, philosophy, literature, history, and culture.

Not only was Coomaraswamy successful in stating the enormous significance of the worship of the Yakṣas and the female Yakṣīs in the iconographic evolution and religious history of India; he also demonstrated their intimate connection with a central feature of Indian myth. This is what has come to be called the Water Cosmology, in which the key concept, as developed in Vedic and Upanishadic literature, is that of the Waters as the basis of existence and the source of all life. Thus what is born of the Waters, what is associated with it, is expressive of life, fullness, completeness, and abundance, as are Yakṣas and Yakṣīs. In this way Coomaraswamy was able to explain the meaning of such popular motifs as the ever present lotus, which, being born of the Waters and living in it, is, from this point of view, a most appropriate symbol of the principle of life, existence, abundance, and prosperity. The

lotus also represents earth, for the earth like the lotus rests on the Waters, which accounts for its appropriateness as support for images of manifest divinities as early as Bharhut. The *makara,* a crocodilian creature, whose habitat is water, and the elephant, which loves to play in water, are also symbols of the Waters, with the same significance as the lotus. It is thus equally natural for the lotus plant to issue from the mouth of the *makara,* a commonly found ornamental motif of Indian art. The Waters themselves are contained in the overflowing vase of plenty, and since the Waters represent life in its abundance, so does the lotus, and it is thus natural for Śrī-Lakṣmī, the goddess of wealth and abundance, to be surrounded by lotus flowers and to be lustrated by elephants, an early image that continues without a break to the present day. And so Coomaraswamy proceeds, one luminous thought following another, so that what had been superficially conceived as the product of the bizarre fantasy of the Indian sculptor began to be understood as a logical and significant system of forms.[30] The meaning of a whole group of motifs found in Indian art is similarly explained by Coomaraswamy with reference to the Water Cosmology and Yakṣa imagery. Add to it the Indian concept that what is truly beautiful is also the source of fullness and abundance,[31] and the necessity of these motifs becomes apparent. Thus ornament becomes not surface decora-

tion but, as Coomaraswamy terms it, "an incitement to the release of more abundant energies."[32]

Coomaraswamy pushed these seminal ideas further in his *Elements of Buddhist Iconography,* first published in 1935, four years after the appearance of the second volume of *Yakṣas.* Here he explored early Buddhist iconography intensively and came to the conclusion that in it is found the first visual representation of concepts expressed symbolically in literature of the Vedic period so that there is as such "nothing specifically or originally Buddhist in early Buddhist imagery, whether visual or verbal." Coomaraswamy holds up for particular attention the representations of the Buddha as a fiery pillar (particularly in sculptures from Amaravati), hitherto ignored by students of Buddhist thought, and demonstrates that they correspond to the Vedic concept of Agni, Fire, who is born of the lotus and is frequently referred to as the pillar that supports all existences. Thus also the representation of the Buddha as the Tree of Life at Sanchi and other sites is related to pre-Buddhist references where it is implied that "all existence, all the worlds, all life, springs up, out, or down into space from its root in the navel, centre of the Supreme Being, as he lies extended on the back of the waters. That tree is his procession in a likeness, the emanation of his fiery energy as light, the spiration of his breath; he is its wise indestructible mover."[33]

SCULPTURE

It is characteristic of Coomaraswamy's work that he never disdained what he called the "mechanical tasks that are the prerequisite to scholarship"; his attempt to explore the underlying meanings beneath the form was preceded by painstaking studies stressing the acquisition of exact and detailed knowledge of the materials. He never turned his back on the taxonomic methods of the natural sciences, methods he learned during his early university training in geology and his years as director of the Mineralogical Survey of Ceylon. This sound grounding in facts enabled him to carry conviction even as he proposed what at first sight seemed a conjectural conclusion. In matters pertaining to Indian art, he seldom succumbed to the temptation to tack art objects onto preconceived speculative chains of thought. Rather his conclusions flowed naturally from a vigorous and profound study of the materials, artistic and otherwise, and to that extent they differ from certain kinds of studies that are now becoming distressingly frequent.[34] Burgess, writing in 1905, was already complaining of what he called antiquaries who "first formed theories more wonderful than natural and then tried to make facts and inscriptions support them."[35] After more than a century and a half of research, there is little excuse for this kind of work. One of the signal values of Coomaraswamy's scholarship is that behind his penetrating exposition of the meaning beyond form there always exists a deep con-

cern for the meticulous study of objects. Those who fail to emulate this speak with that much less authority and carry that much less conviction.

Foreign influence was a central issue in early discussions of Indian sculpture, but after the first quarter of the twentieth century it by and large faded away. Ever since, a great deal of attention has been paid to issues of iconography, and this has always been an important concern of scholars working on Indian sculpture. This is not to say that chronological considerations based on style have been disregarded.

Fergusson, Cunningham, and Burgess were not directly concerned with dating sculpture as such. Their interests were focused on architecture, and if a date could be given to a building, then the date of the sculpture adorning it would naturally follow. Nowhere was it felt that the *style* of sculpture could tell us something about the date of the building. Fergusson, thus, bluntly stated that the difference between a sculpture of the first or fourth century and one of the eleventh or fourteenth was entirely fortuitous and depended totally on the skill of the sculptor and on local circumstances. No wonder progress was painfully slow. It is not surprising that in the 1860s there was not the foggiest notion, for example, of the relative chronology of the sculptures of Bharhut, Sanchi, and Amaravati; and Fergusson was congratulating himself

on having established the priority of the gateway sculptures of Sanchi, though he was able to do this primarily on the basis of historical and paleographical considerations. He did have a faint inkling that the style of the sculpture could perhaps be of some relevance in dating a monument, but so strongly was he convinced of the primacy of architecture that he did not follow up whatever tentative thoughts he may have had on the matter.[36] Nevertheless, and without regard to the methods employed, by the beginning of the twentieth century, when Burgess' active scholarly career was coming to a close, a general outline of the development of Indian sculpture had somehow begun to emerge; and, rather surprisingly considering the circumstances, it was more or less free of any fatal flaws. True, there were errors of detail, some of them grievous, but the system on the whole provided a surprisingly suitable basis for future work.

Grünwedel's work on Buddhist art in India, first published in 1893, was primarily concerned with Buddhist iconography and had little to say about chronology or style. Nevertheless, his belief that the reliefs at Bharhut were "in the same style as the sculpture of the Sanchi gates"[37] makes one gasp, and gives some indication of the really rudimentary state in which studies of sculpture were in spite of the efforts of half a century. But things were soon to change with the great work of

Foucher on the art of Gandhāra. Gandhāran architecture, having largely disappeared due to the vicissitudes of time or, as Foucher wryly recorded, the enterprise of the Military Works Department of the British government, he was forced to concentrate on the sculpture, in which he preferred to see a broad development from work close to its Greek origin toward that which was removed from it. This was a rather simplistic approach, and there was predictable controversy over his conclusions, but in the context of the time it was a great stride forward, setting up, as I have said, new standards of judgment and study in the early twentieth century.

Around the time Foucher was busy at work with Gandhāra, another distinguished French scholar, Gabriel Jouveau-Dubreuil, whose work on architecture I have already discussed, made a contribution to the study of Indian sculpture which proved to be of great influence. As I observed in Chapter 1, Jouveau-Dubreuil was able to postulate, by a recourse to analysis of architectural members, a chronological evolution of south Indian architecture. In a similar manner he established a chronometric scale for south Indian sculpture on the basis of the evolution of motifs, notably the jewelry and the attributes of divinities. Thus, according to him, in the Pallava period Viṣṇu holds a *cakra* without flames between the thumb and index finger; in the Coḷa/Early Coḷa period flames issue from the axle and the edge,

while the *cakra* itself is balanced between the first and middle fingers and is seen head on; in the Pāṇḍya/Late Coḷa period the *cakra* is similar but in front view; in the Vijayanagar period the flames issuing from the axle disappear; and in the Madura period a scarf is present as a decoration (see figure 7).[39] This type of analysis with its chronological implications became quite popular with Indian scholars, particularly in the study of south Indian sculpture, and in conjunction with other evidence it became a standard technique. It was greatly extended, amplified, and refined in the study of south Indian bronzes undertaken in 1932 by F. H. Gravely and T. N. Ramachandran, who also considered many other features of dress and ornament, and also by C. Sivaramamurti in his important work of 1942 on Amaravati and his influential essay of 1959 on geographical and chronological factors in Indian iconography.

While these Indian scholars tempered Jouveau-Dubreuil's approach with other kinds of evidence, a similar method in a much purer and more rigorous form was developed, quite appropriately, by another French scholar, Philippe Stern, and his associates.[40] Like the work of Jouveau-Dubreuil, it was based exclusively on a detailed, careful, and comparative examination of especially selected ornamental motifs in a given art, but in Stern's case the examination is much more compre-

hensive. By a strict application of the technique Stern came up with a series of startling conclusions. Thus, the Lomas Rishi cave in the Barabar Hills, ordinarily thought of as belonging to the third century B.C., he assigned — on the basis of its slender roof, the pairs of elephants between a stūpa-like ornament, and the *makara* with four legs — to the period of Begram and Mathura of the first century A.D., the only time at which similar motifs are known to occur. The famous Didarganj Yakṣi (see figure 8), too, is declared to be of the period after the beginning of the Christian era, on the basis of its coiffure, earrings, necklace, and other details of dress and jewelry.[41]

Here I will not go into the accuracy or lack thereof of Stern's specific comparisons. All that I would like to point out is that though the method is to be commended insofar as it concentrates our attention on the object itself, and though it can be certainly useful in providing clues about date and provenance, the discounting of the quality of sculptural form is fraught with danger. Pushing this method to a logical conclusion, one might conceivably end up assigning an original and its imitation to the same date.

Analytical techniques relying on the comparison of ornament in the Jouveau-Dubreuil manner, as I have said, became part and parcel of a popular tradition of Indian art historical scholarship, underpinning many of

its conclusions. Nevertheless most scholars, particularly those operating under the aegis of the Archaeological Survey of India, worked in a pragmatic manner in a primarily historical context and did not hesitate to utilize a variety of evidence, if in a somewhat ad hoc way, in pursuit of their studies. It is interesting to note that a strong reliance on paleography, evident from the days of Fergusson, and in principle hardly to be distinguished from Jouveau-Dubreuil's ornamental evolution, also became a prominent characteristic of this synthetic approach — it can hardly be called a method — and continues to be widely used to the present day, especially by scholars in India. Paleographical research makes it possible to date an inscription, within broad limits, on the shape of letters. A work of art that happens to be inscribed is thus often dated to the same period as the inscription it carries.[42] Such a method has once again to be used with the greatest of caution, for the conclusions drawn are being deduced not from the work of art itself but from something that happens to be written on it. Used cautiously, paleography can certainly help us as we try to reconstruct chronology, but it cannot determine it. Once again the object itself must be our prime concern; and if indeed the paleographer can help us in our work, we can help him in his. The paleography of an inscription on a sculpture may help in determining its date, but the date of a

sculpture, on the basis of its style, has an equal claim to modify our understanding of the paleography. There is nothing to distinguish one technique as being inherently superior to the other. But it does appear to me that an art historian who relies on the quality of form will do work superior to that of the paleographer who does not.

The emphasis given to paleography draws attention to the pronounced tendency of many concerned with the history of Indian art to rely on the varying conclusions of historians and archaeologists. Thus the date of a particular monument, let us say the sculpture of the great cave temple at Karle, is made to depend on the date of a king named Nahapāna and his adversary the great Sātavāhana ruler Gautamīputra Sātakarṇi, who are associated with the cave. Those who put these kings in the first century B.C. assign the same date to the monument; while those who prefer a date somewhere in the first or second centuries A.D. do likewise.[43] In such a scheme of things the evidence of the style of the monument and its sculptures recedes into the background. A procedure like this makes some sense only when the historical evidence is of a clear and definitive nature; but when the facts of history are themselves most uncertain and contentious, it would seem to me to be quite wrong to rely on them so greatly. Here, perhaps, as Fergusson said such a long time ago, it is art

that should be given an opportunity to fix the ever varying form of history,[44] and not vice versa. It should be possible, for example, to argue on grounds of style that the sculpture of Karle (see figure 9) is closer to Sanchi *torana* sculpture of the first century B.C. than to the school of Mathura of the first century A.D. and later, and if this is indeed the case, that is so much more the reason for supporting a first-century B.C. date for Gautamīputra and Nahapāna rather than a later one. This is the kind of problem that one is faced with again and again, and it would seem to me to be the duty of a historian of art to give priority to the evidence provided by his primary materials. History may yet profit from the evidence of art, though Fergusson's exhortation to this purpose has not won the acceptance it so eminently deserves.

This preoccupation with political history is also reflected in the dynastic classification of ancient Indian art, widely used at present. As I have said, the earliest classifications suggested for Indian art was religious, but this was really a rather slipshod one. Buddhist, Hindu, and Jaina monuments may be distinguished from one another on grounds of subject matter — even though this is not always easy — but by little else, and certainly not on grounds of style.[45] The danger of such a classification is that it begins to suggest to those who use it that essential differences, on grounds of religion, do

exist among the various styles, when as a matter of fact this is quite incorrect in India. Religious classification, though still loosely used today, was clearly untenable and bound to be put aside. It was succeeded by a dynastic one, so that we now hear of Śuṅga, Sātavā-hana, Kuṣāṇa, Gupta styles, and so on. This system is easily the most popular way of characterizing Indian architecture and sculpture today (though oddly enough, not painting).

The dynastic system of classification seems to have begun as a convenient way to designate a style extend-ing for a specific period of time and within a region, which time and region also happened to coincide roughly with the rule of a particular dynasty. This is the way, for example, that it is used by Jouveau-Du-breuil and Coomaraswamy.[46] The usage is again un-derstandable as such, but there are difficulties if we try to apply these dynastic labels too rigorously, for in India we are hardly ever sure about the extent of a territory ruled over by a dynasty, particularly as these territories often expand or contract in response to political or military circumstances. Additionally, the period of time during which a dynasty existed is often uncertain, as in the case of the Sātavāhanas I referred to in connec-tion with the dating of Karle. These are inconve-niences enough, but what is really troublesome is that dynastic classification, like religious classification, sug-

gests to those using it an immediate connection be-
tween the dynasty and the art for which at present there
is, for the most part, little evidence. Except for the
surviving monuments of the Maurya period, by far the
large majority of monuments that have come down to
us from ancient India were built for people other than
members of a royal dynasty. In the Karnatak country,
for example, where there is plentiful inscriptional evi-
dence, of the hundreds of temples erected "in the
Hoyśaḷa kingdom during the reign of the Hoyśaḷas, not
more than half a dozen owe their origin to the ruling
monarchs."[47] If such is the case elsewhere, as with
very few exceptions it seems to be, the part played by
dynasties in the evolution of art becomes very question-
able indeed; but this is precisely what the choice of a
dynastic classification does not suggest. Coomara-
swamy himself was aware of some of these difficulties,
and had begun to realize that "the only adequate classi-
fication is geographical."[48] So also Kenneth de B.
Codrington, who states that "the dynastic periods in
common use are seldom accurately datable, often of
long duration, and always lead to geographical com-
plications. They are moreover archaeologically un-
real."[49]

It is becoming abundantly clear that the style of
Indian art is determined by conditions prevalent during
a period of time in a particular cultural and territorial

unit, and not by any dynastic patronage or ethos.[50] That the artistic traditions of a region continue and are not affected by the constantly fluctuating territories of the various dynasties is also obvious. The only way in which use of dynastic labels can be justified is if we constantly remind ourselves that they are only designations of convenience for a particular period in a particular area and have no other connotations whatsoever. Personally, I believe that their retention always carries with it a potential for false starts and error and that they are best avoided altogether. They make for obscurity rather than clarity, for the simple reason that they encourage erroneous assumptions about the close relationship between a dynasty and art while in fact it is time and space that are at the basis of Indian art. It is not the dynasty that endows a region with its distinctive character. To think otherwise would be, as I have said elsewhere, "to condemn ourselves to a constant wild goose chase, ever following the wrong lead and never sure of the ground on which we walk."[51]

As we survey the progress of studies of Indian sculpture, it becomes increasingly apparent that style did not generally receive the attention and analysis it deserves. We may speculate that this was due, in some degree at least, to the pervasive influence of Fergusson, who though acutely conscious of the central importance of style in the study of architecture did not assign it a

similar importance as far as sculpture was concerned. The problem of style as such in Indian sculpture only began to be tackled seriously in the 1920s. Once again, Coomaraswamy's work, notably his *History of Indian and Indonesian Art,* shows keen insights into the development of form and is full of illuminating remarks, but these remain isolated episodes in the corpus of his work and are not systematically developed. He was sensitive to style, but it was not his main sphere of interest, his chief concern being iconological. True, he postulates a cycle of artistic evolution in India, where we find, as elsewhere, "a succession of primitive, classical, romantic, rococo and finally mechanical forms." He also states that "development at one stage of any artistic cycle is as natural and inevitable as degeneration at another stage,"[52] but he does not follow up and expand on remarks like these. The ideas of J. Strzygowski, who thinks of Indian art in terms of a transition and interplay between the Northern and Southern styles, the former characterized by the Aryan preference for the abstract and symbolic, the latter by a Dravidian preference for anthropomorphic forms, also crops up in Coomaraswamy's work, but once again, he does not do much with them.[53] Stella Kramrisch, herself a student of Strzygowski, also applied these ideas to the study of Indian sculpture, attempting to specify a "medieval factor" on their basis. She was among the first to

explore the relationship between form and meaning in Indian sculpture, notably with her important *Grundzüge der Indische Kunst,* published in 1924 and further expanded in later publications. She placed particular emphasis on the analysis of form if not of its development, magically evoking the spirit of sculpture in a convoluted language full of poetic resonance.[54]

The most rigorous stylistic analysis of Indian sculpture, at least of the early period, is to be found in Ludwig Bachhofer's *Early Indian Sculpture,* first published in 1929. Bachhofer was a student of the great Heinrich Wölfflin, and his approach, reflecting that of his teacher, was an extremely acute and careful stylistic assessment of the subject. He opened up completely new directions in the study of Indian art, which have, unfortunately, not been followed to a desirable extent. There are references in his work, in the manner of Strzygowski, to Aryan and Dravidian, but by and large Bachhofer concentrates on the sculpture itself, providing stylistic insights never before obtained. After making a few preliminary remarks about the Hindu, no doubt meaning the Indian, perception of form, which he characterizes as being endowed with an exceptionally intense feeling for volume, he proceeds to study the sculpture of the Maurya period. Analyzing the famous Maurya lion capitals, he notes the "complete mastery of all the plastic agents of expression . . . and the perfect

reproduction of volume" here at the very beginning of
Indian art, and calls such mastery hardly characteristic
of arts at this stage of development; thus he suspects
that the lion capitals may have been made under foreign
influence. This influence, he believes, came from the
direction of Greece rather than Persia, the reason for
this belief being (and note the stylistic argument) the
marked preference for angular forms in the latter coun-
try. The Didarganj Yakṣī (figure 7) he also assigns to
the Maurya period. He characterizes it as a curious
mixture of a highly developed and a primitive feeling
for form, demonstrating the processes by which, in his
words, a "highly developed art, mastering all the de-
vices of plastic creation, is being adapted to a new and
simple level of conception."[55]

The sculpture at Bharhut (figure 5) Bachhofer ana-
lyzes masterfully, characterizing the modeling as cubi-
cal in form and accompanied by what he calls a desire
for "exhaustive clearness which stipulates also for
clearness of contour." The single parts of the body, he
notes, are only "loosely joined together constituting no
living entity." In the course of time, as at Sanchi, "the
rigidity and severity of line softens, flows more calmly,
and connects the forms more closely together."[56]

He also studies the sculpture of the *toraṇas* of the
Great Stūpa at Sanchi with great sensitivity and empha-
sizes and extolls the delight taken in reality in all of

early Indian sculpture (figure 6). The human body·
"now appears as a beautiful and harmonious volume of
single parts . . . clear, impressive contours sketching
in long strokes the outlines of the image and holding it
safely together." This concept of form, according to
Bachhofer, finds its culmination in the great couples at
Karle (figure 8): "Man and woman," he rhapsodizes,
"stand here one by the side of the other, heroic bodies
full of strength and self assurance. If they are not gods
themselves, they at least challenge with their happiness
the celestial ones."[57]

Analyzing the relief sculpture at Sanchi, Bachhofer
draws attention to the "dark shade . . . (that) nestles
between illuminated figures, covering the entire neu-
tral ground." This he describes as the device of "over-
shadowing," whereby the images are released from the
ground, to which they were pinioned at Bharhut, and
allowed to press "forward to the light, as if anxious for a
place in the sun."[58] The figures, too, are represented in
smoothly interknit rhythms, while at Bharhut each
figure was imprisoned in its own space. This develop-
ment, from the relatively low relief of Bharhut to the
more accomplished and higher relief of Sanchi, had
been accounted for by Marshall as being the result of
West-Asiatic influences, which he deduced from the
occurrence of certain motifs such as winged animals
and the honeysuckle; but this Bachhofer rejects firmly:

"the fact that certain motifs have been adopted does not at all warrant the assumption that the entire form apparatus had also been taken over. The tendency to confound contents and style has already caused so much confusion in the history of Asiatic art that the necessity of drawing a distinction between the two cannot be sufficiently emphasized in the interests of exact knowledge."[59] This is a salutory caution that has not been taken seriously enough.

Remembering the composed and calm forms of Sanchi, Bachhofer notes the changeover in the art of Amaravati from the "stable and the permanent to the transient and mobile." The sculpture at that site, instead of being relaxed and gentle, is marked "by a nervously irritated disposition. All indolence has disappeared, a trembling, almost hysterical unrest having taken hold of man. The wildest transports of joy alternate with outbursts of violent passion. There is neither measure nor goal, everything being done with exuberance and extravagance."[60] Bachhofer finally summarizes the entire development of early Indian sculpture as follows: "The change in the means of representation from a confused and scattered to a collected and regulated style, and thence to free and dissolved forms, as it was effected from Bharhut to Amaravati, was not to remain a unique and special case for India. The movement repeats itself several times dur-

ON THE STUDY OF INDIAN ART

ing the course of its artistic march, naturally with entirely changed bases and with slight variations of measure, until rigidity finally steps in, to which every tropical art is to all appearance destined to fall a victim."[61]

I have quoted at some length from Bachhofer in view of the unique nature of his contribution and his evocative, but at the same time keenly analytical and clear, writing. Whether we agree with him or not, particularly in his attempts to formulate an inner law for the development of style, Bachhofer's work demonstrates a kind of effort that in its concentration on the quality of form tells us things about works of Indian art which we had not heard before. It was an effort to apply a set of principles of art history developed in the West to problems of Indian art, just as was the publication of Strzygowski's articles in English translation by Stella Kramrisch beginning in 1933. It is interesting to note that neither of these two approaches, that of Wölfflin via Bachhofer or that of Strzygowski, was picked up and pursued by Indian scholarship to any appreciable extent. But one need not be discouraged and give up the discourse between East and West as fruitless; and I, for one, am convinced that it is desirable and should be intensified. At the same time, I am not at all asserting that the study of Indian art needs to imitate methods

SCULPTURE

and schemes developed for the analysis of art in the West. Rather, it has to develop its own philosophical basis, which will be naturally rooted in its own circumstances and history. Nonetheless, there can be little doubt of the necessity of entering into communication with new ideas as a means of sharpening our own sensibilities and developing a surer methodology. This is something we have, perhaps, not done enough.

THREE

Painting

The study of Indian painting, compared to that of architecture and sculpture, began relatively late, and is confined for the most part to the twentieth century. Thus its scholarship runs a somewhat different course and does not quite participate in the attitudes and prejudices of the nineteenth century. Much of the Indian painting that remains to us is also of a relatively late date, and belongs to a period the history of which is more securely known, so that scope for speculation is considerably restricted. For example, dynastic classification of painting, except for the name of the Mughal style, did not find favor among scholars. The emphasis on foreign influence as the source of all that is good and beautiful, though present, is considerably toned down, and the cacophonous condemnation of the artistic capabilities of Indians is muted.

Nevertheless, it all began, though only for a short period, in the same distressingly monotonous manner. Sir George Watt, writing in 1904 of the paintings of

Ajanta of approximately the fifth century, considered them more decorative than pictorial, and refused to class them among the Fine Arts; the earliest true pictures, according to him, were the productions of the very much later Mughal painters.[1] This kind of opinion on Ajanta was fortunately very short lived. J. Griffiths, for example, who spent thirteen years copying the paintings, was quick to appreciate their high quality, saying, "here we have art with life in it. human faces full of expression, limbs drawn with grace and action, flowers which bloom, birds which soar, and beasts that spring or fight, or patiently carry burdens; all are taken after Nature's book, growing after her pattern."[2] Few denigrated the quality of the Ajanta paintings thereafter. Lady Christina Herringham attempted to study the style and divided the work into approximately six groups which she took to represent different schools and periods, rather than the steady development of a single school.[3] She was, however, unable to elaborate on this to any great extent, and the study of Ajanta painting on a stylistic basis remains, like so many other things, to be satisfactorily accomplished.

To Sir George Watt, as I have just said, there was first the painting at Ajanta and, after that, nothing else till the Mughal style, which began in the second half of the sixteenth century. In expressing this opinion, Watt was reflecting the state of our knowledge in the early twentieth century. Since then, we have come a very

long way. The gap between ancient India of the fifth
century A.D. and the Mughal period of the sixteenth
century has been filled by the discovery and exposition
of what is variously called the Western Indian or Jaina
style, and the style of Eastern India, also called the Pāla
school, to use its dynastic name. In addition to the
Mughal style, the so-called Rājpūt styles, thought to
have flourished in Rajasthan and the Hill states, have
become well known to us since about the 1920s. The
last thirty years have yielded not only amazing numbers
of Rājasthānī and Pahāṛī miniatures but also rare exam-
ples of preceding styles, knowledge of which is so
fragmentary that they have been given but temporary
names, as is the case with paintings of the Caurapañcā-
śikā (see figure 10) and the Candāyana groups, named
after the manuscripts to which the best or earliest to be
discovered pictures in these styles were attached. And
then there are all the great styles of the Deccan, a
systematic study of which has hardly begun. Nor have
these discoveries ceased, and for a while they were
coming so fast and furiously that scholars were hard put
to keep up with all that poured in. Indeed, our knowl-
edge of Indian painting has improved so greatly over
the years as to be almost unrecognizable from what it
was in the opening years of this century. For reasons of
space, I cannot discuss here all that has been going on.
Rather, I will concentrate on three central styles, the
Mughal, the Pahāṛī, and the Rājasthānī, and, through

their consideration, hope to convey some idea of the nature and progress of studies in this branch of Indian art.

The best known is the Mughal style. On the whole, it was always admired, even if at times somewhat grudgingly, its relative naturalism proving fairly acceptable to early collectors and students whose preferences reflected, for the most part, the pervasiveness of Western taste at the time. Even Havell, who was prone to controverting every cherished opinion, was willing to grant that, though Mughal painting lacked the high spiritual purpose which inspired the old religious school like that of Ajanta, it deserved appreciation and careful study, for the painters were sincere students of nature and had something interesting to say about it.[4]

The first consecutive account of the Mughal style was attempted by Vincent Smith in his *History of Fine Art in India and Ceylon* (1908), an interesting effort in view of Smith's close involvement in the writing of Mughal history. What immediately catches our attention is his preference for the name Indo-Persian, rather than Mughal, by which, he hoped, presumably, to emphasize what he considered to be the derivative character of the painting.[5] The affinities with a scholar like General Cunningham, who had earlier divided Indian antiquities into the Indo-Grecian, the Indo-Scythian, the Indo-Sassanian, and so on, are obvious

(see Chapter 1). Not unexpectedly, Smith was also quite taken with the idea of European influence on Mughal painting (he always adhered to the view that the architect of the Taj Mahal, "the noblest monument ever erected to man or woman," was a Venetian named Geronimo Veroneo), echoing, once again, the current idea that foreign influence was responsible for any quality to be seen in Indian art.[6]

Smith's pioneering account was followed by Percy Brown's *Indian Painting under the Mughals* (1924), a major contribution that carried forward the more positive aspects of Smith's work. Brown's book presented a fairly comprehensive history of the school, and from it we learn much about the general milieu and its sources. The photographic documentation is superb, showing Mughal paintings of the highest quality. Brown's own understanding of style, however, was somewhat limited, and he proceeded on the treacherous assumption that a Mughal picture was of the date of the event it represented, a concession to the historical approach that led him into several blunders. His estimation of Persian and European influence on Mughal painting is a well-reasoned one, and he emphasizes the manner in which artistic elements were transformed even as they were borrowed.[7]

Brown had attempted to map out to some extent the chronological evolution of the style, but had not made

any significant progress; and the subject, as a whole, was rather baffling to students. The first major contribution to a chronological elucidation was made by Hermann Goetz, who developed in 1924 — that is, around the same time as the appearance of Brown's work — a methodology by means of which he hoped to "bring the rich, unnamed, undated material of Indian miniatures into line with general history."[8] This, he said, could be done by taking help from the history of costume. The first step was to reconstruct the history of dress in the Mughal period, and this Goetz was able to do with considerable accuracy by a detailed study of the miniatures and whatever other relevant sources of information as were available to him. He was able, thus, to prove that there was a continual change of fashion throughout the Mughal period, and was also able to establish the type of dress characteristic of each particular period, say the reign of Akbar as opposed to that of Jahāngīr. From here, it was a simple matter to date a miniature on the basis of the dress worn by the figures represented in it. If the figure wore a dress from the Akbar period, the miniature was of the Akbar period, and so on. This method won extremely wide acceptance, and, as we shall shortly see, strongly influenced all subsequent studies, not only of the Mughal style, but of all other kinds of Indian miniature painting.

Popular as this method was and continues to be, you will recall that in essence it is not different from that suggested by Jouveau-Dubreuil in his study of south Indian sculpture a decade earlier (see Chapter 2), except that instead of the attributes of divinity it is the dress of mortals that here outlines the chronology of art. The two methods share both advantages and shortcomings, the most troublesome of the latter being the too exclusive reliance on pattern rather than quality of form, so that this method taken alone does not make it possible to distinguish an original from a copy; and this problem of copying is certainly more acutely felt in studies of Indian painting than in those of sculpture (see figure 11).

E. Kühnel, Goetz's collaborator in the important work *Indian Book Painting* (1926), reveals that earlier stereotyped prejudices as seen in studies of architecture and sculpture continued to be alive to some extent in the study of Indian painting as well. Kühnel thus flatly characterizes Mughal artists as "plagiarists and compilers rather than original geniuses," the source of the plagiarisms being European engravings well-known at the Mughal court. "Figures apparently purely Indian and taken from life [are] in reality skillfully disguised plagiarisms from European engravings. This is shown especially in certain groupings which appear natural enough but whose intention can better be explained by

the problems of Western art." He does not elaborate further. The very fact that European work was present implied that it was copied. The painters were not only plagiarists, Kühnel continues, but lacking in individuality, and "abjectly dependent on the wishes and commands of the imperial patron." This last idea seems to be enjoying a considerable revival in our own time.[9]

A new chapter in the study of Mughal painting — and, for that matter, Indian miniature painting in general — opened with the publication in 1929 of Ivan Stchoukine's appropriately entitled work *La Peinture Indienne à l'époque des Grands Moghols,* for long the classic work on the subject. A student of the distinguished French art historian Henri Focillon and of Foucher, the great scholar of Gandhāra art, Stchoukine was primarily moved by methodological considerations, and he evolved a rigorous method that heavily emphasized style, subject matter being of secondary importance. Concentrating on an analysis of form, movement, proportion, color, and composition, and a careful study of the methods of rendering nature, animals, and man, Stchoukine built up a clear idea of various Indian, and to the relevant extent, Persian components of Mughal painting. By placing the study of Mughal painting in this broad context, he was able to demonstrate the strongly indigenous nature of the Mughal style and also to throw a flood of light on its

development and its relationship with Rajput painting, which he insisted on calling "l'art regional."[10]

As a result of these extensive researches Stchoukine was able to trace the development of Indian painting as a whole far more clearly than had ever been done before. He began with ancient Indian painting of the type found at Ajanta, characterizing its qualities as classical renderings of well-developed and free forms marked by a perfect balance between the ideal and the real. During the medieval period that followed, dominated by what he called the Jaina or Western Indian style, occurred a transformation toward the primitive and the rigid, with forms fixed by artificial canons rather than by natural inspiration. With the coming of the Mughals these congealed traditions, according to Stchoukine, melted away, Indian painting cast off the lethargy into which it had been plunged for centuries, and there was a brilliant renaissance. The fashion for painting, well established at the imperial Mughal court, was imitated at the court of the vassal princes as well, leading to the establishment of the various centers of Rajput painting.[11]

The founding of the Mughal empire opened the door to foreign, particularly Persian, influences, which were rapidly transformed or relegated to a place of secondary importance. Thus, to Stchoukine, the term Indo-Persian that had been used for Mughal painting was en-

tirely inappropriate. Mughal painting, according to him, very early in its history became a part of the Indian artistic current, though it always retained some memories of its Persian apprenticeship in the delicacy of brushwork, the sweeping line, and the rich palette. European influence was also present, if only in a broad and general manner, but in never the same proportion as the Iranian, and it also was successfully assimilated. This influence is clearly evident in the naturalistic tendencies of the style, particularly in portraiture, but on the whole it is of secondary importance, the Indian elements being always in the forefront. Firmly convinced, thus, of the Indianness of Mughal painting, Stchoukine naturally rejected the view that Mughal painting was apart from the other equally Indian style, the Rajput. To him there were no such things as a secular Mughal and a religious Rajput art; both of them were a part of one unified vision, the difference being one of stylistic variation rather than anything else. In his conclusion, he reaffirmed that "it is in art itself that we must search for the laws that govern it. Its forms are never imposed from without, but are born with it, are the art itself." Where other scholars saw a diversity of sources and currents, Stchoukine envisioned a profound unity of Indian art.[12]

Stchoukine's well-considered, balanced, and methodologically sound work, which sees Indian painting as

a consistent whole, has remained the standard work on Mughal painting since its publication. The only criticism that we may hesitatingly bring against it is that the quality of form is not sufficiently explored, and that Stchoukine is often content with a comparison of pattern. This shortcoming has been since remedied to a great degree in the work of Robert Skelton, Keeper of the Indian Section of the Victoria and Albert Museum, and Stuart Cary Welch, Curator of Hindu and Muslim painting at the Fogg Art Museum at Harvard University. As a result of their gifted connoisseurship, the focus of research in Mughal painting has shifted from the style of periods to that of individual artists, witnessed by their studies of the artists Farrukh Beg and Basāwan.[13] These kinds of work have led to a refined understanding of style not yet seen in the study of Indian art. I have myself been able to support Stchoukine's assertion of the Indianness of Mughal art by a concrete demonstration of the actual manner in which pre-Mughal styles were absorbed and transformed by the artists of Akbar to yield the Mughal style proper; evidence of this process is to be seen in the precious manuscript of the *Tūṭī-nāma* in the collections of the Cleveland Museum of Art.[14]

Besides the Mughal style, the other great tradition of Indian painting is called the Rajput style. Surprisingly, its existence went unrecognized until 1912, when

ON THE STUDY OF INDIAN ART

Ananda Coomaraswamy, whose profound contribu-
tions to the study of architecture and sculpture I dis-
cussed earlier, published the very first account of the
subject. This was followed in 1916 by his famous
work *Rājpūt Painting,* which, it is hardly an exaggera-
tion to state, changed entirely the understanding of
Indian painting. This book is a relatively short but
most remarkable work on a subject Coomaraswamy felt
very deeply about. And considering the meager mate-
rials then known, it is full of perceptive thoughts and
amazing intuitions, some backed up with facts, some
not, but many of which, after a whole cycle of scholar-
ship, can be demonstrated to be correct or nearly so.
The subject matter and themes of the art are set out
with great sensitivity, and a bold attempt is made to
understand the nature of the style and its evolution by
drawing analogies with the development of language
and literature. Coomaraswamy realized the impor-
tance of what he calls the "classification by age," and
though he himself, not surprisingly, erred in these
matters, this does not in any way detract from his basic
contributions to conceptual understanding.[15]

What Coomaraswamy called Rajput painting, thus
distinguishing it from the Mughal manner, was a style
he theorized to have extended from the early thirteenth
century (though he was unable to reproduce any exam-
ples which he thought to be earlier than the sixteenth

century) to approximately the middle of the nineteenth century. The nature of the relationship of this style to the earlier classic art of India was, according to him, the same as that of the north Indian vernaculars to classic Sanskrit literature. He rejected the term "Hindu" for this art as being sectarian, but chose instead, surprisingly enough, the even narrower term "Rājpūt," which is a name of a ruling class among the Hindus. The reason he put forward for doing this was his belief that these works of art were entirely produced under Rājpūt patronage.[16] This assertion is, generally speaking, correct, though paintings were made for other sections of society also, and in this sense there is really no Rājpūt painting as such, as there is no painting of the Brahmin or other castes, but only guilds or groups of painters making works of art for patrons of whatever creed or caste as were able to secure or wanted their services. The term "Rājpūt," however, has passed into general usage and is acceptable if we understand it in the sense Coomaraswamy used it; but, unfortunately, as I have said, there is a general tendency for terms to lose the qualified sense in which they were first used. The literal meaning begins to take precedence, so that names acquire a life of their own with all the attendant distortions of understanding.

Rājpūt painting, so-called, was divided by Coomaraswamy into two broad groups, Rājasthānī and Pahāṛī, a

distinction that continues to be used to the present day. He also noted that the Rājasthānī style was not confined to the states of Rājasthān, as the name would seem to imply, but spread to adjoining areas; he even suggested an eastern extension to Orissa and Bengal, as demonstrated by the painted book covers of that region, a broad and daring conception of the so-called Rājpūt style as one with nationwide implications that is quite likely to be proven accurate. Coomaraswamy also speculated on the possibility of Mathura's having been a center at an earlier date, a remark of particular significance as concrete evidence builds up for the Caurapañcāśikā group's provenance being the region of Delhi/Agra in the sixteenth century or earlier.[17] Though he did not expressly say so, Coomaraswamy's remarks as a whole imply that the Rājpūt style was a pan-Indian affair spread out over almost all of north India; and the possible objections to this view become weaker with time. After all, the Western Indian style, just preceding it, as has now been established, was a style of national scope,[18] flourishing not only in the north but also in the south, and there is no reason why the Rājpūt style should not be thought of as a national style as well, at least for north India, even though the full evidence, notably from the Gangetic valley, is not yet in.

If the Western Indian style and the Rājpūt style are indeed of wider denotation than their names suggest, it

would perhaps be wise to have names for them that would more truly reflect their character. In an attempt to cope with a problem of just this type, that is, of freeing a style from names with inappropriately narrow connotations, Rai Krishnadasa renamed the Western Indian or the Jaina style, as it had been earlier called, the Apabhraṁśa style, on analogy with Apabhraṁśa language and literature; this name is not bounded by narrow geographical and sectarian confines, as the literature was produced in all parts of the country for people of various religions and many walks of life.[19] It might thus be desirable to have a similar term free of narrow geographical and class connotations for what Coomaraswamy called Rājpūt painting; but, then again, the term may have become irreplaceable, being too well-entrenched in our language. I am trying to stress, as I did in the earlier chapters on architecture and sculpture, that there is at this juncture a pressing need to think through the basic problems of classification and nomenclature and to make sure that these encourage rather than inhibit the growth of knowledge.

Coomaraswamy's pioneering work emphasized an understanding of the subject matter rather than the building up of an elaborate apparatus of names and dates, this in keeping with the kind of information available to him. But, as fresh materials continued to be discovered, the energy of scholars was naturally

directed toward an understanding of stylistic develop-
ment also. It was Pahāṛī painting that first received the
more intensive study, for the simple reason that it was
the Pahāṛī miniature that was the first to become a
marketable commodity. The well-known Amritsar
dealer Radha Krishna Bharany played a crucial part in
this process, so that the great majority of pictures dis-
cussed by Coomaraswamy both in the *Rajput Painting*
of 1916 and in the *Boston Museum Catalogue* of 1926
were of the Pahāṛī school. Studies were subsequently
directed toward the elucidation of provenance and the
determination of chronology, culminating in Karl
Khandalavala's *Pahāṛī Miniature Painting,* published in
1958. Pahāṛī painting was divided by Khandalavala
into three broad groups, one a style of great power
called the Basohlī school, which lasted roughly from
the end of the seventeenth to the middle of the eigh-
teenth century, followed by a transitional style he
called the pre-Kāngṛā, and culminating in the lyrical
works of the Kāngṛā *kalam* (school) that extended
roughly from the 1780s well into the nineteenth cen-
tury. All three, Basohlī, pre-Kāngṛā, and Kāngṛā, de-
veloped local idioms at various centers spread through-
out the hills. Flatly denying the existence of any
school of miniature painting in the hills earlier than the
Basohlī school of the late seventeenth century, Khan-
dalavala thought that Pahāṛī painting itself originated

around 1675 as a result of the strong Mughal influence of the Aurangzeb period, probably exercised through the agency of an artist trained in that school, and not from any contact with Rājasthānī painting. He noticed a sudden change in Pahārī painting from the 1740s onward, which he related to intermittent incursions of painters trained in the contemporary Mughal idioms of the Muḥammad Shāh period, this transitional phase leading from around 1760 onward to the Kāngrā style proper which continued to flourish until almost the mid-nineteenth century.[20] Much of Khandalavala's reasoning seems to have been based on an examination of costume, a continuation of the methodology of Goetz, and shows but small concern for the formal content of style. It is, nevertheless, important as the first major attempt, after Coomaraswamy, to classify the Pahārī schools appropriately and to develop a systematic chronology.

Even as Khandalavala's book was being published, large numbers of new Pahārī miniatures were being discovered in undisturbed private collections, mostly due to the indefatigable efforts and researches of M. S. Randhawa. Fresh studies were undertaken by W. G. Archer, who had a long interest in the subject, and by B. N. Goswamy, Jagdish Mittal, and others, each contributing a fresh point of view. Particularly noteworthy is Goswamy's attempt to build up an account of the

ON THE STUDY OF INDIAN ART

painters and their families from a painstaking study of pilgrim accounts and government land records, leading to an emphasis on the family as a basis for style.[21] All of this vigorous effort culminated in Archer's encyclopedic and magisterial account of the history of Pahārī painting, published in 1973, which will remain an indispensable work for a long time to come. Archer adheres to a classification that is based on the political division of the area into a number of states, and he attempts to reconstruct the development of painting in each of the erstwhile kingdoms by employing style, history, and a variety of other criteria. His views are likely to be controversial, but, clearly focused and buttressed by judicious discussion as they are, they will do a great deal to advance further research and understanding.

The study of Rājasthānī painting had been inaugurated by Coomaraswamy in his *Rājpūt Painting* of 1916, but he was able to do little with it because of the sheer paucity of material. The earliest surviving miniatures he could reproduce were from the now famous Boston *Ragamālā* series, which he dated to around 1600; a mid-seventeenth century date is generally accepted at present.[22] Earlier miniatures, he speculated, had been lost or destroyed for a variety of reasons, constant internal warfare being an important one. This shortage of data prevented any significant advance in scholarship,

but things decidedly began to look up around the 1950s with the entry into the art market of a great mass of miniatures previously in the possession of the ruling families of Rājasthān. Public and private collections both in India and abroad were remarkably successful in acquiring important examples, and these became the basis of scholarly researches of considerable importance. Slowly, painfully, and step by step, the great individual schools of Rājasthān began to be isolated. The outline of the central school of Mewar was the first to emerge, and we have a fairly clear idea of the development of this style from the powerful *Rāgamālā* series from Chawand dated, in my opinion, to A.D. 1575, a time when Rāṇā Pratāp was in full flight before the Mughal army of Akbar.[23] The Mewar idiom seems to have lasted up to the nineteenth century.

The Malwa style, to which the Boston *Rāgamālā* belongs, was also clarified considerably, and its progress in the seventeenth century was clearly charted. New information is now beginning to emerge that should give us some idea of this style in the eighteenth century. It also increasingly appears that the school was not confined to Malwa, but extended over a fairly large portion of central India.[24]

A completely new style with strong Mughal leanings was discovered to have flourished at Bikaner,[25] and we can now reconstruct a connected history from at least

the mid-seventeenth century onward. A remarkable feature of this school is the relatively individualistic work of painters and the large number of inscribed paintings giving the names of painters with dates, so that it is possible to attempt accurate stylistic studies of some depth and refinement. The existence of the strong Mughal influence at Bikaner forces us to rethink the relationship between the schools of Rājasthān and the Mughal style.

A brilliant school with a long history and great productivity was discovered to have flourished in a region called Hāḍautī in Rājasthān, which largely comprised the later princely states of Bundi and Kota.[26] It produced a style of refined line, brilliance of color, and vigorous movement existing from the later sixteenth to the late nineteenth century, among its great achievements being some wonderful pictures of the hunt. To realize that about thirty years ago this richly productive school was quite unknown gives us some inkling of the extent of recent discoveries.

Several other Rājasthānī schools have also been greatly clarified in recent years; yet others remain to be studied. Thus, the history of the school of Amber/Jaipur has been pushed back to the seventeenth century, and the evolution and development of the school of Kishangarh are also becoming clear.[27] This and much more has been accomplished, and it is amazing how our

knowledge of Indian miniature painting has been changing from year to year. Materials have come to light in such rapid succession that scholarship has been unable to cope with all that has been discovered. Particularly informative are the discoveries of earlier material, which have made the origins of the school the subject of fascinating study. We thus have the magnificent works of the Caurapañcāśikā group, a complete mystery once upon a time, and now at the center of a group of wonderful paintings. These appear to date from the early sixteenth century, not to speak of yet others of a similar type which served as the source not only of the Rājasthānī but also of the Mughal style.[28]

Along with this rapid accumulation of rich new knowledge, scholarship on Indian painting does face certain problems and difficulties that deserve thoughtful consideration. The first of these is a physical one, but nevertheless of such consequence that I cannot fail to mention it. The dispersal of traditional collections and the building up of modern ones, while in a certain odd sense welcome, inasmuch as it makes available to a wider public and to scholars works of art the existence of which was previously unknown, also makes necessary the time-consuming reassembling of these fragmented materials. The peculiar conditions of the art market have obscured the sources whence the paintings came, as large series of paintings have been broken up

and sold to a vast assortment of collectors, many of them to vanish from sight or later reappear at the most unexpected places. As our studies progress, it is becoming increasingly obvious that the dispersed nature of the data often makes considered judgments impossible. Fortunately, several catalogs of temporary exhibitions, beginning with the memorable Khajanchi exhibition of 1960, and a series of shows held over the past twenty years by the Asia Society have helped in bringing together some of the scattered corpus.[29] A careful documentation is an important need of the times.

As one surveys Rājasthānī painting of the last thirty years and more, some distinct trends become apparent. There is, first of all, a study of the works of art heavily relying on a comparative study of the dress and jewelry worn by the figures, decorative motifs, the treatment of landscape, architecture, and so on. It is what has been perhaps unfairly called an "archaeological" study, emphasizing pattern rather than form, and it parallels the contemporary work on Indian sculpture and architecture, in which most scholars, with but a few exceptions like Bachhofer, used similar techniques. Since Hermann Goetz's work of the 1920s, attempts to fix the relative chronology of styles of miniature painting have relied especially heavily on analysis of costume. While useful to some extent, the method has severe limitations, most recently exemplified by the work of Khan-

dalavala, whose persistence in dating entire schools on the basis of the presence or absence of a single item of dress, the *cākadāra jāmā* (tunic with pointed corners at the hem), seem quite excessive and counterproductive.[30]

The study of the formal aspects of painting, placing the greatest emphasis on visual comprehension in preference to that of subject matter, is a much needed corrective to a point of view that sees works of art merely as items of cultural expression. Nevertheless, it is well to remember Coomaraswamy's observation that "while it is true that aesthetic beauty does not depend directly on the subject of a work . . . such beauty as they have has only arisen from the necessity which has been felt to express their subject matter."[31] This is a particularly widespread Indian attitude toward the value to be found in art, and this being the case, continual emphasis must be paid to an understanding of the themes displayed by the paintings. This is something on which we have not labored enough since Coomaraswamy spelled out in felicitous language the subject matter of Rājpūt painting, a feature that is quite unexpected, for in studies of Indian sculpture the opposite is the case (see Chapter 2). The task is arduous, involving a variety of skills including an understanding of political, social, cultural, and economic history, as well as an easy grasp of contemporary literature, which is

ON THE STUDY OF INDIAN ART

closely related to the painting. None of this is really possible without a sound knowledge of the language and also of epigraphy. The crucial necessity of being able to read correctly manuscripts or the inscriptions on the paintings, whether they set out themes, or identify portraits, or, in rare instances, give a date or provenance, should be obvious; yet relatively few scholars of Rājasthānī painting are capable of doing this. The work of B. N. Goswamy and V. C. Ohri has done much to remedy the situation for Pahārī painting with its exasperating Ṭākarī script, but much remains to be done for Rājasthānī painting. Inscriptions should be published whenever possible; for otherwise we are too often left with nothing to rely on but the testimony of a scholar whose ability to read and understand inscriptions is of the most dubious character. The publication of inscriptions would throw them open to critical discussion and, thus, encourage epigraphical studies and give scholars a chance to make up their own minds about readings.

The necessity to render a subject pictorially can be understood only in the context of the circumstances of the time when it was produced, and scholars have been increasingly concerned with this context. There are, however, certain well-entrenched impediments that need to be mentioned. One of the most notable is the

uncritical acceptance of the Rājpūts and Rājpūt history as seen through the eyes of James Tod, the early nineteenth-century chronicler of these matters. Tod's contributions, valuable as they are in view of his sympathy for the subject, often seem now to be a curious combination of learning, romance, fantasy, partisanship, and even imperial arrogance, whether conscious or subconscious. The view of the Rājpūt princes, for example, as simple and brave warriors, but somewhat uncouth and barbaric, is clearly untenable, but continues to pervade much writing about their art. They were, on the contrary, often rulers of great cultural sophistication and achievement, as accomplished as the Mughals in their own cultural context. We have among them, in every dynasty, a galaxy of learned kings who personally made great contributions to literature, patronized outstanding poets and litterateurs, erected superb buildings, and encouraged every kind of artistic activity.[32] Nevertheless, Tod continues to be relied upon heavily, and I suggest that this is largely due to an unawareness of the extremely valuable traditional historical literature (such as the *khyāta* of the type written by Muhaṇota Naiṇasī) produced in Rājpūt kingdoms and also of more recent works written in the Hindi language.[33] There exists a considerable body of studies far superior to Tod's history, namely the great

and compendious *Vīra-Vinoda* of Śyāmaladāsa, written almost a hundred years ago, and G. H. Ojha's *Rājapū-tāne kā itihāsa,* published in the 1930s, not to mention the extremely important contributions to periodical literature, references to which are scant and largely symbolic in current writing in art history. There are also now available for study the invaluable records of the Rajasthan State Archives, which should throw a flood of light on the social, cultural, and economic circumstances in which the works of art were pro-duced. The copious indigenous literature of Rā-jasthān, now being rapidly published or existing in manuscript form, is also going to be extremely help-ful. I am perhaps dragging out a point unreasonably, but the present state of affairs with its large amount of simply unqualified writing forces me to emphasize the ability to cope with language if future studies of Rā-jasthānī art are to achieve excellence.

Furthermore, one must attempt to avoid simplistic explanations often based on unproved assumptions. There is, for example, the constant association of art with a peaceful political situation, and the corollary that art declines in times of war and troubles. This simply is not proven as far as Indian miniature painting is concerned; great works have been created in the most troubled of times (witness the Chawand *Ragamālā*

mentioned earlier). Nor should this be a matter of surprise, for the art hardly involves any great expenditure of money.

None can deny the importance of patronage to painting, but there is a tendency among some scholars to make too close an equation, as if the artist were little more than an alter ego of the patron, so that if the patron was troubled the art was haunting and nostalgic, and so on.[34] The whole problem of patronage, particularly in the Rājasthānī context, has to be examined very carefully before any such sweeping assertions can be made. There must surely have been rulers whose tastes in painting affected the style of the artist, but there must also have been many others who took little or no interest in painting, leaving the artist to follow his own devices. If the patron inspired the artist, it is equally possible for the artist in turn to have molded the patron's taste. We are also aware of the long absences of Rājpūt rulers from their homes in the imperial service, and this would surely have affected the nature of relationship between patron and artist. All of these are factors that must be taken into account and judiciously weighed before any viable conclusions can be drawn. A close study of the evidence will naturally lead to considerations of a general and theoretical nature, but until this careful accounting is honestly done, unproved

hypotheses should not be allowed to congeal into indisputable beliefs.

The intimate relationship postulated between the artist and patron has led to the division of paintings of a given school on a regnal basis, and we hear, for example, of works of the Karṇasiṁha period, the Rājasiṁha period, and so on. This may be a convenient way of dividing time, but its uncritical acceptance implies that the style of painting changed in some way from one reign to the other, and leads to distortions that are best avoided. A related matter, once again, is the division of style on the basis of relatively modern political units, each state a priori considered to have a distinct style of its own. On the basis of the evidence, this does seem to be largely true, for many modern states correspond to ancient cultural units; but it is not always or necessarily true. If it were, every time a state was divided or the territory of one was absorbed by another, a new style would be born, or the style of a given area would change; and this is by no means established. Actually, it would seem to be much more reasonable to divide style on a regional basis, these regions defined by a distinct local culture or language, and to pay less attention to the precise political boundaries of later states. A type of classification based on space and time is being increasingly adopted with great success in the study of ancient Indian architecture and sculpture, and I suspect

that something along these lines would be equally useful for the study of painting.[35] Influences, too, it must be noted in this connection, have always traveled from one part of India to another, people moving fairly freely over the entire country. Frontiers were not sealed or passports canceled with the growth of political tension; pilgrims, in particular, carried on their pious activities throughout times of peace or war. Nor is there any reason for believing that the various regions of India were isolated from one another until acts of a political nature, whether peaceful or warlike, brought them into contact. If this had been the case, the remarkable consistency of style over the entire subcontinent from the earliest to modern times would hardly have been possible.

These are but a few ideas we have to face as we proceed with future studies, not only of Indian painting, but also of architecture and sculpture. Enough work has now been done for us to step back, take some stock of the situation, and critically examine some basic concepts that lie at the roots of our thinking. The validity of basic assumptions and classifications that so strongly orient our thoughts needs to be scrutinized and, if necessary, changed; or, if not changed, at least given new meaning. The study of style and form needs to be intensified without losing sight of the subject of the art; the understanding of the historical,

ON THE STUDY OF INDIAN ART

social, cultural, and economic context has to be deep-
ened; and the relationship of art to other forms of
artistic expression, notably literature, has to be more
intimately understood. The scope for research is end-
less, and it is my hope that this book will be of some use
to those who will grapple with the problems of Indian
art in the future.

NOTES

REFERENCES

INDEX

N O T E S

INTRODUCTION

1. See for example Coomaraswamy 1932, pp. 213–220.
2. For an extensive, illustrated account see Mitter 1977.
3. Stein 1912, vol. 2, pp. 22–26.
4. See P. Chandra 1975.

I. ARCHITECTURE

1. Mitter 1977, pp. 106–108, 148.
2. M. Archer 1980.
3. Wilson 1841, p. 3.
4. From the preface by one Captain Harkness; Ram Raz 1834, p. iii.
5. The text has been frequently studied. See particularly the works of Acharya.
6. Having won great popularity in his time, Fergusson's work, apart from his contributions to Indian architecture, almost passed into oblivion. Recently there have been some attempts at reappraisal. See Craig 1968 and Pevsner 1972; the latter is of the opinion that "a book on Fergusson would be well worth while" (p. 239, n. 1).
7. Fergusson 1849, p. xiv; 1876, vol. 1, p. 228.

8. Fergusson 1877, p. 5.
9. Fergusson 1849, p. xiv.
10. Fergusson 1876, pp. vi – vii.
11. Fergusson 1873, p. vi; 1876, p. vi.
12. Fergusson 1876, vol. 1, p. 228.
13. Fergusson 1849, p. xiv.
14. Fergusson 1862, pp. 1, 4.
15. Schliemann 1885, dedication page.
16. Fergusson 1873, p. 168.
17. Fergusson 1877, p. 6.
18. Fergusson 1876, p. 21.
19. Fergusson 1845, p. 1.
20. Cunningham 1873, p. iv.
21. Cunningham 1880, p. 110.
22. Cunningham 1872, p. xx.
23. Ibid., pp. xix – xx.
24. See for example *Epigraphia Indica* 2 (1894): 199 ff.
25. Cunningham 1873, p. 2 ff.
26. Fergusson 1880, p. 31.
27. Burgess 1905, p. 147.
28. Burgess and Cousens 1903, p. vi.
29. Jouveau-Dubreuil 1914, vol. 1, p. 4.
30. Ibid., p. 51 ff.
31. Ibid., p. 5. He later amended this grouping slightly, sub-
 stituting early Coḷa for Coḷa and later Coḷa for Pāṇḍya. See
 Jouveau-Dubreuil 1917, p. 36.
32. Jouveau-Dubreuil 1914, vol. 1, p. 8.
33. As quoted in Allchin 1961, p. 342.
34. Jouveau-Dubreuil 1914, vol. 1, p. 152.
35. Schapiro 1953, p. 287.
36. Jouveau-Dubreuil 1914, vol. 1, p. 2.
37. Fergusson 1884, pp. vi – vii.
38. Havell 1913, p. v.

39. Havell 1915, p. viii.
40. Acharya's first publication making use of such texts appeared in 1918, his last in 1946.
41. Coomaraswamy 1928, pp. 250 – 275.
42. Coomaraswamy 1931, pp. 203 – 205.
43. What follows is summarized from Coomaraswamy 1938.
44. Mus 1935.
45. Kramrisch 1946.
46. Dhaky 1963.
47. Dhaky 1975.

2. SCULPTURE

1. Jouveau-Dubreuil 1914, vol. 1, p. 168.
2. See Mitter 1977, esp. chaps. 1 and 2.
3. Fergusson 1876, p. 36.
4. Fergusson 1873, pp. 89, 107, 155.
5. Ibid., pp. 169, 173.
6. Ibid., p. vi.
7. Cunningham 1854, pp. 125 – 126.
8. Cunningham 1879, p. 11.
9. Ibid., p. vii.
10. Cunningham 1873, pp. 23 – 25.
11. Burgess 1887, p. 112.
12. Burgess and Cousens 1903, p. 31.
13. Burgess 1870, p. 9.
14. Prinsep 1838, pp. 156 – 157.
15. Foucher 1918, vol. 2, p. 496.
16. Stein 1912, pp. 22 – 26.
17. Marshall 1922, pp. 621, 620, 625, 632. The same views are defended in Marshall and Foucher 1942, pp. 103, 156 – 159.

18. Havell 1928, preface to 1st ed., p. x: Indian fine art is not "a form of artistic cretinism but an opening into a new world of aesthetic thought."
19. Ibid., pp. 28 ff.
20. *Journal of the Society of Arts* 58 (March 4, 1910): 425.
21. Rothenstein et al. 1910.
22. Coomaraswamy 1927, p. 52.
23. Harle 1974, p. 23.
24. Fergusson 1873, p. ix. The ideal scholar to study Indian sculpture, according to Fergusson, was one who knew the languages, had made a special study of ancient India, possessed a practical knowledge of Indian art and architecture, and had long familiarity with Indian modes of expressing feelings in material representations.
25. Marshall and Foucher 1942; Foucher 1920, 1900.
26. Fergusson 1877, p. 11.
27. Banerjea 1941.
28. Coomaraswamy 1930, p. 3.
29. Coomaraswamy 1928, 1931.
30. Coomaraswamy 1931, pp. 13 ff., 56 ff., 47 – 48, 61 ff.
31. Oldenberg 1927, p. 98.
32. Coomaraswamy 1939, p. 379.
33. Coomaraswamy 1935, pp. 91, 8.
34. See P. Chandra 1983.
35. Burgess 1905, p. 133.
36. Fergusson 1873, pp. vi, 169, 178.
37. Grünwedel 1893, p. 23.
38. Jouveau-Dubreuil 1914.
39. Ibid., vol. 2, pp. 64 – 65.
40. For a brief statement on the method see Stern 1972, pp. 149 – 152. He developed the technique in connection with the study of Khmer sculpture in 1927. The first major application to Indian art appeared in 1954.

41. Stern 1954, pp. 30 ff, 41.
42. See Banerji 1933; Shah 1959; Dehejia 1972.
43. Khandalavala and Chandra 1956 – 57, pp. 11 – 26; Dehejia 1972, pp. 13 ff.
44. Fergusson 1873, p. 11.
45. For a recent refutation of religious classification see Stern 1972, pp. 131 – 132.
46. Jouveau-Dubreuil 1914, vol. 1, pp. 56 ff.; Coomaraswamy 1927, p. 71.
47. Settar 1975, p. 37.
48. Coomaraswamy 1927, p. 107.
49. Codrington 1930, p. vi.
50. A. Ghosh in M. Chandra 1962; Dhaky 1968, p. 307; and A. Ghosh 1974, pp. 5 – 6.
51. P. Chandra 1975, p. 36.
52. Coomaraswamy 1927, p. 72.
53. Ibid., pp. 5, 8, 290. Strzygowski was a professor at the Kunsthistorischen Institüt of the University of Vienna who rejected the conventional points of view then held in favor by the European art historical establishment. Simply stated, he began his researches by seeking to establish the existence of a north European center in opposition to the Mediterranean as the source of European artistic traditions. Thence he proceeded to postulate a grand generalization according to which there were essentially two centers, that of the "North," theoretically placed at the north pole, and that of the "South," theoretically placed at the equator, and that universal art was to be understood as an interaction between the two. His clearest statement on the art of India in the context of his theories is to be found in two articles, Strzygowski 1928, 1933.
54. Kramrisch 1933, pp. 103, xi. Also see Kramrisch 1924a and Marshall 1924.

55. Bachhofer 1929, pp. v, 6 – 7, 10.
56. Ibid., pp. 2, 21, 22.
57. Ibid., p. 36.
58. Ibid., p. 37.
59. Ibid., p. 47.
60. Ibid., p. 54.
61. Ibid., p. 118.

3. PAINTING

1. Watt 1904, p. 454.
2. Griffiths 1896 – 1897, pp. 7 – 9.
3. Herringham 1915, p. 141.
4. Havell 1928, p. 224.
5. Smith 1911, p. 450.
6. Smith 1911, pp. 417 – 418.
7. Brown 1924, pp. 56, 57, 170.
8. Kühnel and Goetz 1926, p. 43.
9. Ibid., p. 48.
10. Stchoukine 1929, p. 170.
11. Ibid., pp. 133, 17, 163, 57 – 58.
12. Ibid., pp. 164, 166, 170, 171.
13. Skelton 1957; Welch 1963.
14. P. Chandra, 1976.
15. Coomaraswamy 1916, pp. 2, 11.
16. Ibid., p. 1.
17. Ibid., p. 11; P. Chandra 1976, p. 40.
18. M. Chandra 1949, p. 21.
19. Krishnadasa 1939, pp. 71 – 72. The literary and linguistic analogy in the manner of Coomaraswamy 1916, p. 2, is noteworthy. I find the nomenclature acceptable but the

opprobrious connotation (*apabhraṁśa*= corrupt) not very satisfying.

20. Khandalavala 1958, pp. 68 ff., 117, 220.
21. Goswamy 1968.
22. Coomaraswamy 1916, Pls. 1–3.
23. P. Chandra 1976, p. 49, n. 51.
24. Krishna 1963.
25. See Goetz 1950; Khajanchi 1960.
26. Chandra 1959; Beach 1974.
27. Andhare 1972; Dickinson 1959.
28. Khandalavala and M. Chandra 1969; P. Chandra 1976, pp. 37–42.
29. Khajanchi 1960; Welch and Beach 1965; Welch 1973.
30. See P. Chandra 1976, p. 39.
31. Coomaraswamy 1916, pp. 6–7.
32. Kaul 1968, for example, documents their considerable contributions to literature: Pṛthvīrāja of Bikaner, Nāgarīdāsa (Sāvantasiṁha) of Kishangarh, and Brajanidhi (Pratāpasiṁha) of Jaipur are poets of the first rank in the history of Hindi literature.
33. For a brief account, particularly of Muhaṇota Naiṇasī, see Rāṇāvata 1981.
34. Thus Goetz 1950, p. 108; Welch 1973, p. 60.
35. M. Chandra 1962, pp. 9–13; Dhaky 1968, p. 307; P. Chandra 1975, pp. 35–36.

REFERENCES

Acharya, P. K. 1918. *A Summary of the Manasara.* Leiden.
———— 1946. *An Encyclopaedia of Hindu Architecture.* London.
Allchin, F. R. 1961. "Ideals of history in Indian archaeological writing." In C. H. Philips, ed., *Historians of India, Pakistan and Ceylon.* London.
Andhare, S. K. 1972. "A dated Ragamala and the problem of provenance of the eighteenth century Jaipuri paintings." *Lalit Kala* 15:47 – 51.
Archer, Mildred. 1980. *Early Views of India.* London.
Archer, W. G. 1973. *Indian Paintings from the Punjab Hills.* 2 vols. London.
Banerjea, Jitendra Nath. 1941. *Development of Hindu Iconography.* Calcutta.
Banerji, Rakhal Das. 1933. *Eastern Indian School of Medieval Sculpture.* Calcutta.
Beach, Milo C. 1974. *Rajput Painting at Bundi and Kota.* Ascona.
———— 1976. "An early European source in Mughal painting." *Oriental Art* 22:180 – 188.
Bhattacharya, Benoytosh. 1924. *The Indian Buddhist Iconography.* Calcutta.
Bhattacharya, Brindavan Chandra. 1921. *Indian Images: The Brahmanic Iconography.* Calcutta.

REFERENCES

Bhattasali, Nalini Kant. 1929. *Iconography of Buddhist and Brahmanical Sculptures in the Dacca Museum.* Dacca.

Brown, Percy. 1924. *Indian Painting under the Mughals.* Oxford.

Burgess, James. 1870. *Memoir on the Survey of Architectural and other Archaeological Remains.* Bombay.

———— 1887. *The Buddhist Stupas of Amaravati and Jaggayyapeta.* London.

———— 1905. "Sketch of archaeological research in India during half a century." *Journal of the Bombay Branch of the Royal Asiatic Society,* extra number, pp. 131–148.

Burgess, James, and Cousens, Henry. 1903. *Architectural Antiquities of North Gujarat.* London.

Chandra, Moti. 1949. *Jaina Miniature Painting from Western India.* Ahmedabad.

————, ed. 1962. *Seminar on Indian Art History, 1962.* New Delhi.

Chandra, Pramod. 1959. *Bundi Painting.* New Delhi.

———— 1975. "The study of Indian temple architecture." In Pramod Chandra, ed., *Studies in Indian Temple Architecture.* New Delhi.

———— 1976. *Tūṭī-nāma of the Cleveland Museum of Art and the Origins of Mughal Painting.* Graz.

———— 1983. Review of J. Williams, ed., *Kalādarśana: American Studies in the Art of India. Ars Orientalis* 14.

Codrington, K. de B., ed. 1930. *A History of Fine Art in India and Ceylon* by Vincent A. Smith, 2nd ed. rev. by K. de B. Codrington. Oxford.

Coomaraswamy, Ananda Kentish. 1912. "Rajput painting." *Burlington Magazine:* 315–324.

———— 1916. *Rajput Painting.* London.

———— 1926. *Catalogue of the Indian Collections in the Museum of Fine Arts, Boston, pt. V, Rajput Painting.* Boston.

———— 1927. *History of Indian and Indonesian Art.* New York.

REFERENCES

——— 1927. "Origin of the Buddha Image." *Art Bulletin* 9 (June):287–317.

——— 1928. "Indian architectural terms." *Journal of the American Society of Oriental Art* 48:250–275.

——— 1928; 1931. *Yakṣas.* 2 vols. Washington, D.C.

——— 1930. "Early Indian architecture: cities and city-gates." *Eastern Art* 2:209–135.

——— 1930. "Indian sculpture: a review." *Rupam,* nos. 42–44, pp. 2–11.

——— 1931. "Bodhigharas, Palaces." *Eastern Art* 3:181–217.

——— 1932. "Reactions to art in India." *Journal of the American Society of Oriental Art* 52:213–220.

——— 1938. "Symbolism of the dome." *Indian Historical Quarterly* 14:1–56.

——— 1939. "Ornament." *Art Bulletin* 21:375–382.

Craig, Maurice. 1968. "James Fergusson," in John Summerson, ed., *Concerning Architecture.* London.

Cunningham, Alexander. 1854. *The Bhilsa Topes.* London.

——— 1872; 1873. *Archaeological Survey of India, Reports.* Nos. 1 and 3.

——— 1879. *The Stupa of Bharhut: A Buddhist Monument Ornamented with Numerous Sculptures Illustrative of Buddhist Legend and History in the Third Century B.C.* London.

——— 1880. *Archaeological Survey of India, Reports.* No. 10.

Dehejia, Vidya. 1972. *Early Buddhist Rock Temples.* Ithaca, N.Y.

Dhaky, Madhusudan A. 1968. "Some early Jaina temples in northern India." *Shri Mahavira Jaina Vidyalaya Golden Jubilee Volume,* Pt. I. Bombay.

——— 1975. "The genesis and development of Maru-Gurjara temple architecture." In Pramod Chandra, ed., *Studies in Indian Temple Architecture.* New Delhi.

Dhaky, Madhusudan A., and Nanavati, J. M. 1963. "Ceilings in

REFERENCES

the temples of Gujarat." *Bulletin of the Baroda Museum and Picture Gallery* 16–17:1–117.

Dickinson, E. and Khandalavala, Karl. 1959. *Kishangarh Painting.* New Delhi.

Dowson, John. 1914. *Classical Dictionary of Hindu Mythology and Religion, Geography, and Literature.* London.

Epigraphia Indica 2 (1894).

Fergusson, James. 1845. *Rock Cut Temples of India.* London.

———1849. *An Historical Enquiry into the True Principles of Beauty in Art.* London.

———1862. *History of the Modern Styles of Architecture.* London.

———1873. *Tree and Serpent Worship: or Illustrations of Mythology and Art in India in the First and Fourth Centuries after Christ from the Sculptures of the Buddhist Topes at Sanchi and Amaravati.* London.

———1876. *History of Indian and Eastern Architecture.* London.

———1877. *On the Study of Indian Architecture.* London.

———1880. *Cave Temples of India.* London.

———1884. *Archaeology in India.* London.

Foucher, A. 1900. *Étude sur l'iconographie bouddhique de l'Inde.* Paris.

———1905; 1918; 1923. *L'Art gréco-bouddhique du Gandhara.* 3 vols. Paris.

———1920. *Rapport préliminaire sur l'interpretation des peintures et sculptures d'Ajanta.* Bombay.

Ghosh, Amalananda, ed. 1974. *Jaina Art and Architecture,* Vol. 1. New Delhi.

Goetz, Hermann. 1924. "Kostüm und Mode an den indischen Fürstenhofen des 16.–19. Jahrhunderts." *Jahrbuch der Asiatische Kunst* 1.

———1950. *The Art and Architecture of Bikaner State.* Oxford.

———1959. "Imperial Rome and the Genesis of Classic Indian Art." *East and West* 10:153 ff.; 261 ff.

REFERENCES

Gopinatha Rao, T. A. 1914. *Elements of Hindu Iconography.* 4 vols. Madras.

Goswamy, B. N. 1968. "Pahari painting: The family as the basis of style." *Marg* 21:17–62.

Gravely, F. H., and Ramachandran, T. N. 1932. *Catalogue of the South Indian Hindu Metal Images in the Madras Government Museum.* Madras.

Griffiths, J. 1896–1897. *The Paintings in the Buddhist Cave Temples of Ajunta.* London.

Grünwedel, A. 1893. Buddhistische Kunst in Indien. Berlin.

Harle, James C. 1974. *Gupta Sculpture.* Oxford.

Havell, E. B. 1913. *Indian Architecture.* London.

——— 1915. *Ancient and Medieval Architecture of India.* London.

——— 1928. *Indian Sculpture and Painting,* 2nd ed. London.

Herringham, Christina Jane. 1915. *Ajanta Frescoes.* London.

Journal of the Royal Society of Arts 58 (March 4, 1910):286 ff.

Jouveau-Dubreuil, G. 1914. *Archéologie du sud de l'Inde.* 2 vols. Paris.

——— 1917. *Dravidian Architecture.* Madras.

Kaul, Rajakumari. 1968. *Rājasthāna ke rājagharānon kī hindī sevā.* Jaipur.

Khajanchi, Motichand. 1960. *Miniature Painting: A Catalogue of the Exhibition of the Sri Motichand Khajanchi Collection,* by Karl Khandalavala, Moti Chandra, and Pramod Chandra. New Delhi.

Khandalavala, Karl. 1958. *Pahari Miniature Painting.* Bombay.

Khandalavala, Karl, and Chandra, Moti. 1956–1957. "Date of the Karle caitya." *Lalit Kala* 3–4:11–26.

——— 1969. *New Documents of Indian Painting: A Reappraisal.* Bombay.

Kramrisch, Stella. 1924a. "Influence of race on early Indian art." *Rupam* (April):73–76.

——— 1924b. *Grundzuge der indischen Kunst.* Hellerau.

——— 1933. *Indian Sculpture.* London.

——— 1946. *The Hindu Temple.* Calcutta.

Krishna, Anand. 1963. *Malwa Painting.* Varanasi.

Krishnadasa. 1939. *Bhārata kī citrakalā.* Varanasi.

Kühnel, E., and Goetz, Hermann. 1926. *Indian Book Painting.* Berlin.

Mallmann, Marie-Thérèse de. 1948. *Introduction a l'étude d'Avalokiteśvara.* Paris.

——— 1963. *Les Enseignements iconographiques de l'Agni Purana.* Paris.

——— 1964. *Étude iconographique sur Mañjuśrī.* Paris.

Marshall, John. 1922. "The monuments of ancient India." In *Cambridge History of India,* I, 612–649.

——— 1924. "Influence of race in early Indian art." *Rupam* (April):69–73.

Marshall, John, and Foucher, Alfred. 1940. *The Monuments of Sanchi.* London.

Mittal, Jagdish. 1962. "New studies in Pahari painting." *Lalit Kala* 12:26–35.

Mitter, Partha. 1977. *Much Maligned Monsters: History of European Reactions to Indian Art.* Oxford.

Mus, Paul. 1935. *Barabudur.* 2 vols. Hanoi.

Ojha, G. H. 1932–1939. *Rājapūtāne kā itihāsa.* 6 vols. Ajmer.

Oldenberg, H. 1927. "Vedic words for 'beautiful' and beauty and the Vedic sense of the beautiful." *Rupam* (October): 98–121

Pevsner, Nikolaus. 1972. "James Fergusson." In *Some Architectural Writings of the Nineteenth Century.* Oxford.

Prinsep, James. 1838. "Discovery of the name of Antiochus the Great in two edicts of Asoka, king of India." *Journal of the Asiatic Society of Bengal* 7:156–67.

REFERENCES

Ram Raz. 1934. *Essay on the Architecture of the Hindus.* London.

Rāṇāvata, Manoharasiṁha. 1981. *Itihāsakāra muhaṇota naiṇasī tathā usake itihāsa-grantha.* Jodhpur.

Rothenstein, William, et al. 1910. Letter to the Editors, *The Times,* February 28, p.6.

Schapiro, Meyer. 1953. "Style." In *Anthropology Today.* Chicago.

Schliemann, H. 1885. *Tiryns: The Prehistoric Palace of the Kings of Tiryns.* New York.

Settar, S. 1975. *Hoysala Sculpture in the National Museum, Copenhagen.* Copenhagen.

Shah, U. P. 1959. *Akota Bronzes.* Bombay.

Sivaramamurti, C. 1942. *Amaravati Sculpture in the Madras Government Museum.* Madras.

——— 1959. "Geographical and chronological factors in Indian iconography." *Ancient India* 6:21–63.

Skelton, Robert. 1957. "The Mughal artist Farrokh Beg." *Ars Orientalis* 2:393–412.

Smith, Vincent A. 1911. *A History of Fine Art in India and Ceylon.* London.

Sompura, Prabhashankar. 1960. *Dīpārṇava.* Palitana.

Stchoukine, Ivan. 1929. *La Peinture indienne à l'époque des Grands Moghols.* Paris.

Stein, Aurel. 1912. *Ruins of Desert Cathay.* 2 vols. London.

Stern, Philippe. 1927. *Le bayon d'Angkor et l'évolution de l'art Khmer.* Paris.

——— 1954. "Les ivoires et os découverts à Begram, leur place dans l'évolution de l'art de l'Inde." In *Nouvelles recherches archéologiques a Begram.* Paris.

——— 1972. *Colonnes indiennes d'Ajanta et d'Ellora: évolution et répercussions.* Paris.

Strzygowski, J. 1924. "Die Asiatische Kunst." *Jahrbuch der Asiatische Kunst* 1:1–18.

REFERENCES

———— 1928. "The Orient or the North." *Eastern Art* 1:69–85.

———— 1933. "India's position in the art of Asia." *Journal of the Indian Society of Oriental Art* 1:7–17.

Śyāmaladāsa. 1886. *Vīra-vinoda.* 4 vols. Udaipur.

Tod, James. 1829; 1832. *Annals and Antiquities of Rajast'han or the Central and Western Rajpoot States of India.* 2 vols. London.

Welch, Stuart Cary. 1963. "The paintings of Basawan." *Lalit Kala* 10:7–17.

———— 1973. *A Flower from Every Meadow.* New York.

Welch, S. C., and Beach, Milo C. 1965. *Gods, Thrones, and Peacocks.* New York.

Watt, George. 1904. *Industrial Arts of India.* London.

Wilson, H. H. 1841. *Ariana Antiqua.* London.

INDEX